IMAGES
of America

CLINTON AND THE
TOWN OF KIRKLAND

IMAGES
of America

CLINTON AND THE
TOWN OF KIRKLAND

Faye Cittadino and Frank Cittadino

ARCADIA
PUBLISHING

Copyright © 2012 by Faye Cittadino and Frank Cittadino
ISBN 978-0-7385-7680-0

Published by Arcadia Publishing
Charleston, South Carolina

Printed in the United States of America

Library of Congress Control Number: 2011934735

For all general information, please contact Arcadia Publishing:
Telephone 843-853-2070
Fax 843-853-0044
E-mail sales@arcadiapublishing.com
For customer service and orders:
Toll-Free 1-888-313-2665

Visit us on the Internet at www.arcadiapublishing.com

This book is dedicated in memory of our parents—Evelyn and Glenn Talmadge and Julia and Joseph Cittadino—and to all who wish to learn more about this special community.

CONTENTS

ACKNOWLEDGMENTS

We are so grateful to those individuals, many who remain unknown to us, who documented through photography and written notes the events, people, and places that formed the basis of our research and the content of this book.

In many instances, their early cameras and photographic processes were at best cumbersome and at worse totally unpredictable. It is only by the diligence of others that these precious images have survived. We encourage the readers of this book to consider documenting the life and times of their own communities and neighborhoods so that future generations may better understand and appreciate their history.

Thanks especially to Clarence Aldridge, Katherine Collett, Esther Delaney, Gil Goering, Carol Hernandez, Shirley Nester Hooson, Bill Huther, Jean and William Kay, Jack Lane, Robert Meelan, Cheri Misiak, Karen Ostinett, Virginia and Vincent Romanelli, Erin Vosgien, the Clark Mills Fire Department, the Clinton Fire Department, and Hamilton College, LutheranCare.

To the best of our knowledge, all images are courtesy of the Clinton Historical Society unless otherwise noted.

INTRODUCTION

Clinton and the Town of Kirkland, with its hamlets of Clark Mills, Franklin Springs, Kirkland, and Chuckery, have indeed been very special places to live since their beginnings in the late 1700s. Legend has it that a scouting party of two men came to the area of the present Village Green during the fall of 1786 from their homes in Connecticut after serving in the Revolution and being engaged at the nearby Battle of Oriskany. Seeking shelter, they spent the night enveloped by the roots of a large upturned tree.

The following spring, a band of eight families led by Capt. Moses Foote came back to this then heavily wooded area with the intention of creating a new home in the wilderness. The tree is no more, but the Village of Clinton and the Town of Kirkland still grow and prosper with a wonderful quality of life.

Known as "Schooltown," it has been home to over 60 private and public schools since its founding. Some lasted but a short time and were located in many of the stately homes throughout the town. Others merged to form the Clinton Central School District. One of the earliest schools, the Hamilton Oneida Academy, was established in 1794 by Rev. Samuel Kirkland, an early missionary to the Oneidas of the Iroquois Federation. In 1812, it became Hamilton College, the third oldest college in New York State and one of the oldest in the nation. Its success is a testimony to the importance this community has placed on education.

Over the years, a wide variety of businesses have come and gone. A short time after settling here, a gristmill was erected by Capt. James Cassety on the banks of the Oriskany Creek near the present-day College Street Bridge. A tributary of the Mohawk River, it flows south to north through the town.

Later, iron ore was discovered by a farmer plowing his fields on the eastern end of the town. Formally identified as Clinton hematite, it originally was transported to smelters outside of town. Soon underground mines and two large furnaces were developed in outlying hamlets of the town that used the Chenango Canal and, later, the railroads to take the pig iron to early American industries.

Another accidental discovery that influenced the town's economy and changed the name of the early hamlet of Franklin Foundry to Franklin Springs was a particularly high-quality, naturally carbonated mineral water. Formal tests showed that it rivaled that of the best European waters, and it gave birth to yet another new industry.

In the hamlet of Clark Mills, huge cotton, wool, and silk mills developed, bringing hundreds of new residents from their homes in England, while the nearby hamlet of Kirkland became a favorite vacation getaway during the early to mid-1900s before it was home to the Kirkland Foundry.

Of course, a major factor that attracted and encouraged that group of eight families to settle this land was the fertile soil amidst picturesque rolling hills. This provided a vibrant early economy based on agriculture and the development of countless family farms.

As the years passed and transportation evolved from horse and buggy to canal, to train travel, then trolley, and eventually the automobile, so did the town's cultural diversity. During its earliest days, opera houses, musical groups, movie theaters, early literary societies, and art groups were developed. Today, residents and visitors enjoy a wide variety of cultural events provided by the town, the Kirkland Art Center, the Clinton Historical Society, Hamilton College, local performing arts groups, and the public school.

Our intention in writing this book is to bring about a deeper understanding and appreciation of the rich heritage that has made Clinton and the entire Town of Kirkland such a special place to live, attend school, and visit.

One

AROUND TOWN

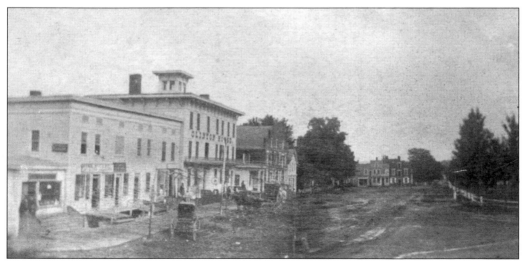

The Village of Clinton and the Town of Kirkland, with its hamlets of Clark Mills, Kirkland, Franklin Springs, and Chuckery, have always been very desirable places to live, offering a combination of small-town friendliness and a degree of sophistication. This image from the mid-1800s shows a number of early businesses, including the three-story Clinton House hotel and restaurant, unusual for a community of Clinton's size.

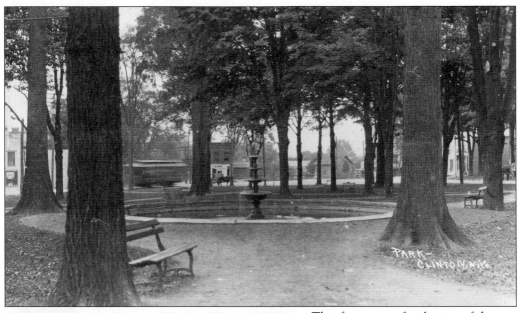

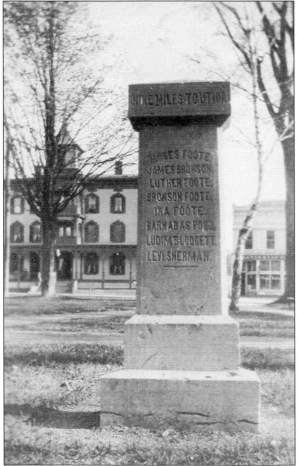

This fountain, a focal point of the Village Green since the mid-1800s, originally received its water from a small pond on Fountain Street that was carried in a variety of early pipes, including those carved from wood. A section of original wood pipe may be found in the museum in the Clinton Historical Society. Although a decorative element in the landscaping of the present green, the fountain served as an important water source for early firefighters.

Located on the southern portion of the Village Green at what is believed to be the very site of the Old White Meeting House, the Founder's Monument recognizes the courage and vision of Capt. Moses Foote and the seven other families who settled Clinton on March 3, 1887. All the men had been Revolutionary War soldiers from Connecticut who liked what they saw when they engaged in battles throughout the Mohawk Valley.

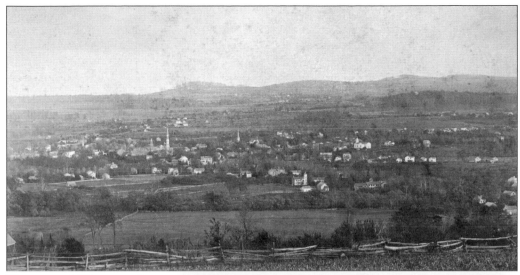

This view of Clinton and the early Town of Kirkland was taken from the Rogers Farm on Bristol Road. The town's early settlers enjoyed fertile farmland and waterpower from the Oriskany Creek that bisected the town.

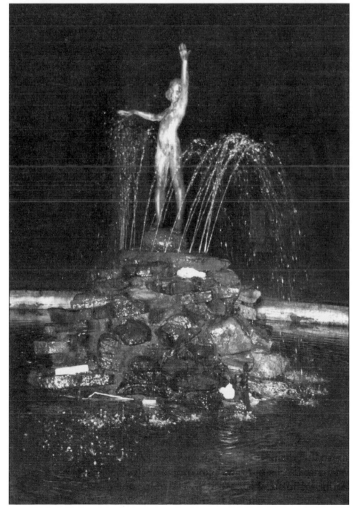

Gracefully pointing toward the former Houghton Seminary, in operation on Chestnut Street from 1861 to 1903, this bronze statue was created by American sculptor Edward Beige as a gift from the alumni of the seminary to the town in 1939. It was their hope that the statue might preserve the memory of their beloved school so that it would not be forgotten. Here, it is placed in the fountain redesigned by Utica architect R. Clement Newkirk.

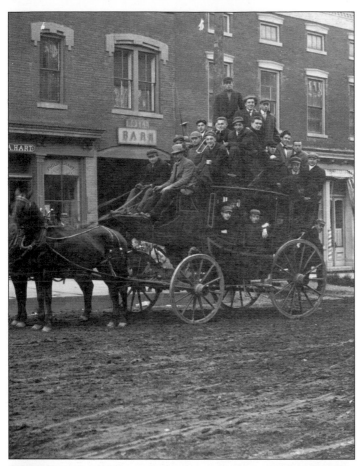

The village and its many restaurants and taverns, especially the elegant Clinton House restaurant, provided a taste of the big city to visitors and residents. This photograph is believed to be of a group of Hamilton students about to head back up the hill. The relationship between Hamilton students and the village has always been a close one.

Some young ladies of the Houghton Seminary on Chestnut Street are photographed in front of the stately Gallup House on September 29, 1884.

After the fire of 1862, Dr. James Scollard, a local physician, purchased the former Tower Block and began an extensive rebuilding both inside and out, which included an entrance from the popular Clinton House Hotel and restaurant. He also added the distinctive mansard roof with its ornamental ironwork incorporating the words "Opera House." It soon became the site of a variety of community events, including basketball games, silent movies, and dances. It was reportedly one of the first locations in the area to show a talkie.

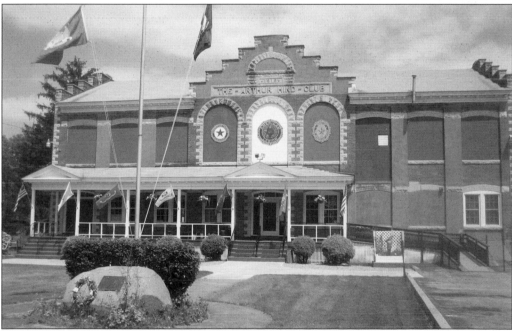

Entertainment for the employees of the world-famous Hind & Harrison Plush Company and their families was provided by the Arthur Hind Club. Attracting workers from far and wide to the picturesque hamlet of Clark Mills, the club offered a wide variety of social opportunities, including a café, a store, various games, and a spacious second-floor theater that showed first-run films. Clark Mills American Legion Post No. 26 has occupied this building since 1946. (Courtesy of Frank Cittadino.)

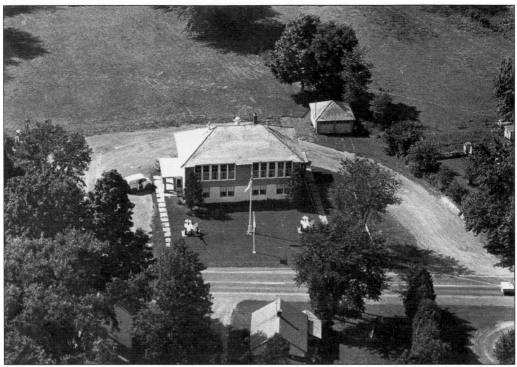

The Helmuth Ingalls Post of the American Legion in the hamlet of Franklin Springs also occupies a historic structure. Originally used as the Franklin Springs Schoolhouse before school centralization in the 1930s, it also became a furniture store before the American Legion took it over in 1948.

Photographed from Kellogg Street looking south toward West Park Row, this was a popular route for students from the Male Division of the Clinton Liberal Institute and the Kellogg Young Ladies Seminary on their way to the village.

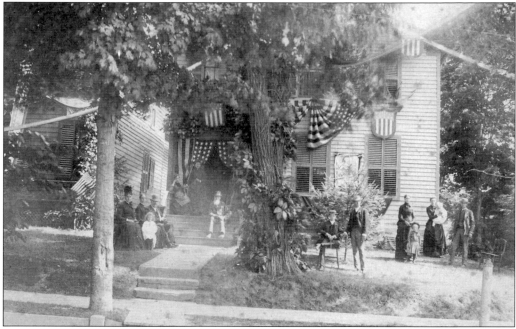

This house, located at 26 Utica Street, was the childhood home of Pres. Grover Cleveland. Here, it is pictured all decked out with bunting and streamers as it waits to greet the president upon his visit to help Clinton celebrate its bicentennial in 1887.

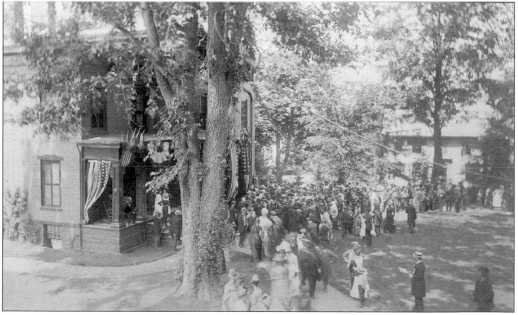

There was tremendous excitement throughout the region when news that the 22nd president of the United States would visit Clinton. Here, the president and first lady Francis Cleveland greet residents and visitors on the lawn of the home of the Honorable Othniel Williams, located at West Park Row, in anticipation of the 1887 bicentennial festivities. The parade was over a mile long, with the president and first lady in the viewing stand, which was set up in front of the Stone Church.

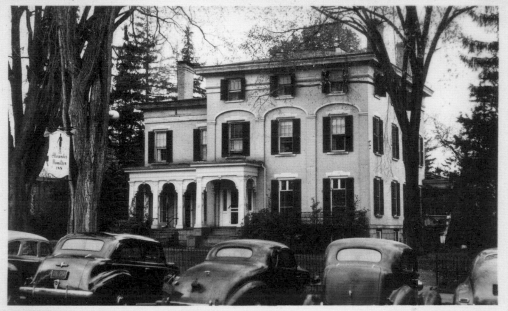

437—THE ALEXANDER HAMILTON INN, CLINTON, N. Y.

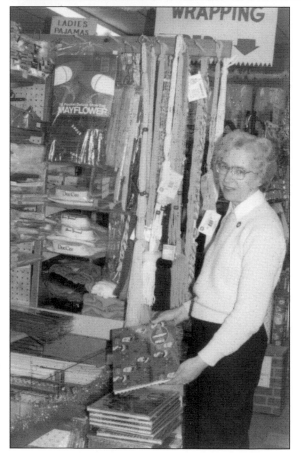

Othniel Williams's family home, located across from the Village Green, has seen many uses through the years. It once operated as the very elegant Alexander Hamilton Inn in honor of the man who gave his name to Hamilton College and served as the first secretary of the US Treasury, developing America's modern-day system of currency. It has since been the site of many excellent restaurants and is currently the Alexander Hamilton Institute.

The real charm of the Town of Kirkland extends beyond its picturesque New England beauty and is centered on the warmth and friendliness of its residents and their businesses. Virginia Romanelli, seen here adjusting inventory in the family's well-stocked Gorton's variety store during the 1970s, knew most of her customers by name. (Courtesy of Virginia and Vincent Romanelli.)

16

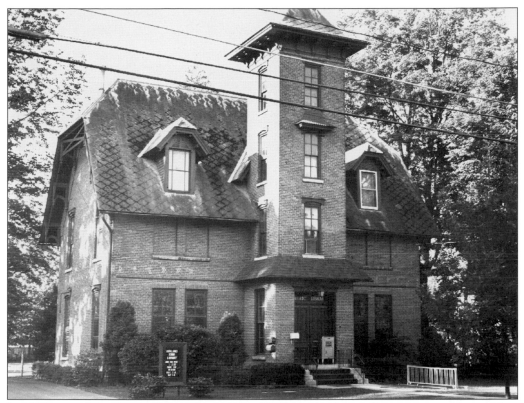

In 1901, a number of women from the town and college saw the need to create a public and free library for the entire Town of Kirkland. With a modest 1,000 volumes, they rented two rooms in the former Sigma Phi Hall fraternity house on College Street. Thus the Kirkland Town Library was born. After countless bake sales and other fundraising events, they were able to purchase the building for $3,000. The library's large second floor has served as a temporary home for early community organizations such as the Kirkland Art Center and the Clinton Historical Society.

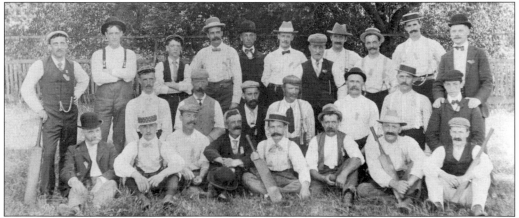

Photographed here is the Clark Mills–Clinton cricket team. Becoming the national sport of England by the end of the 18th century, along with so many early residents arriving from the British Isles to work in the textile and mining industries, it was only natural that cricket became popular here. Many believe that soccer was also introduced into the region from the many English families living in Clark Mills. (Courtesy of the Clark Mills Historical Society.)

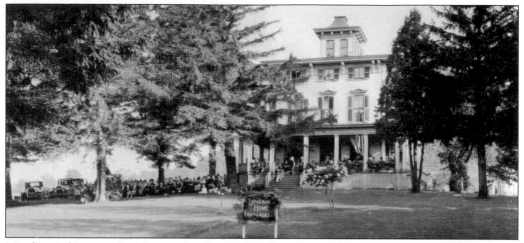

Martha Herbig owned a 13-room farmhouse at trolley stop no. 14 on Utica Street. Herbig's dream to create a home to compassionately care for others gave birth to the original Lutheran Home for the Aged and Infirm, which has since become LutheranCare. Now, with state-of-the-art facilities, it provides a variety of programs and services to those in need of care at a number of locations throughout the Town of Kirkland. (Courtesy of LutheranCare.)

Though it was a famous landmark for over a century, few photographs exist of the interior of the Park Hotel. It quickly became known for its elegance and as gathering place not only for community members but also for visitors wishing to spend the summer in Clinton.

18

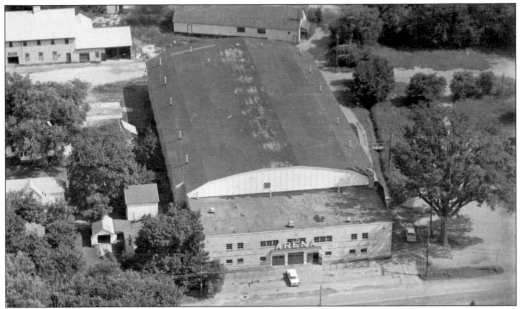

Erected in less than a year after a devastating fire destroyed the first stadium, which was constructed in 1948, this new arena was built of concrete and opened in 1954 to a standing-room crowd anxious to cheer for the Clinton Comets. Drawing fans from neighboring states and Canada, the Comets brought national recognition to Clinton and the Town of Kirkland as a "Hockeytown" and helped create enthusiasm throughout the upstate region for this relatively new sport.

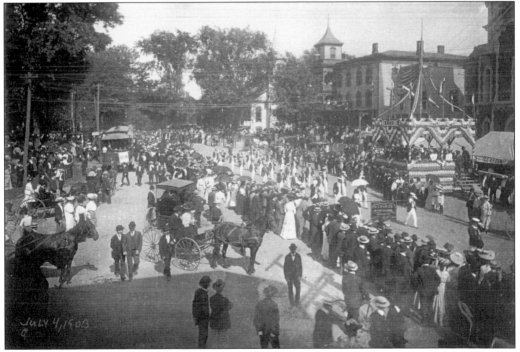

South Park Row is the focus of activity during the County Firemen's Convention held in Clinton on July 3 and 4, 1903. The Park Hotel and Baptist church can be seen to the right. Note the formal dress complete with hats during this summer celebration.

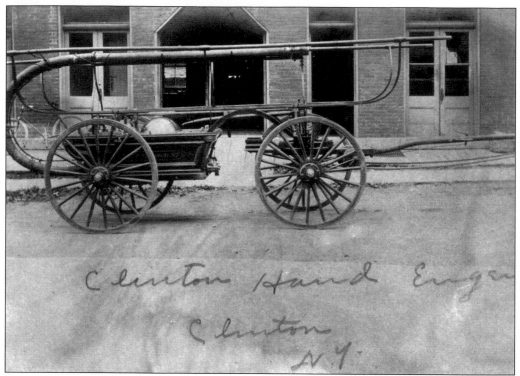

Clinton Hand Engine Clinton N.Y.

The Clinton and Clark Mills Fire Departments have had extremely dedicated members since the early days of the town. Shown in this photograph is the first piece of firefighting equipment of Clinton's newly formed Smyth Hook and Ladder Company. It was housed in the first recorded firehouse at the rear of the Onyan Block on Williams Street during the late 1800s and early 1900s.

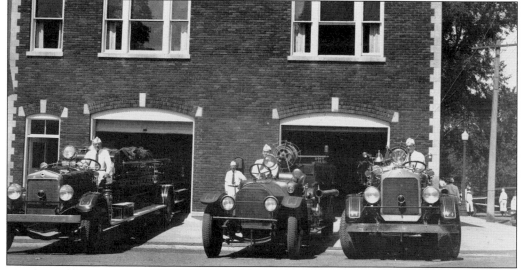

Members of Clinton's fire department proudly display early mechanized fire engines in this 1932 photograph. The very first was a pumper purchased in 1923 and built on a 1914 Pierce Arrow chassis. With a village appropriation of $6,000, the firemen were able to purchase a converted 1923 Model T roadster equipped with two chemical tanks and another Pierce Arrow automobile adapted to carry ladders.

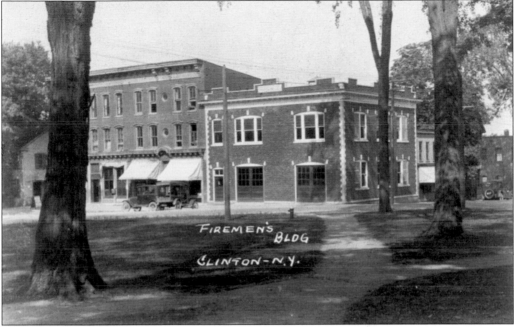

Located on North Park Row on the site of the former Fake's Store, Firehouse No. 1 was constructed in 1921 in part through a bequest from Ralph S. Lumbard.

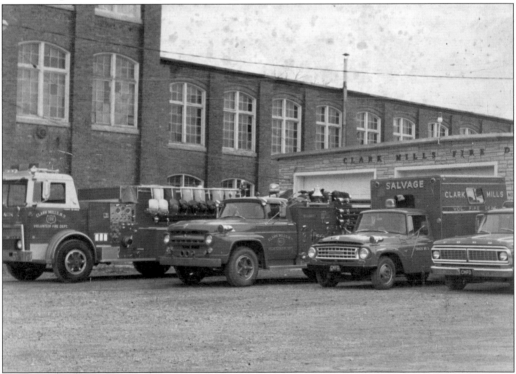

Seen here are the trucks of the Clark Mills Fire Department in front of the firehouse next to the former Hinds & Harrison Plush Company. Present-day plans call for using the well-maintained factory buildings for apartment and condominium living. (Courtesy Cheri Misiak.)

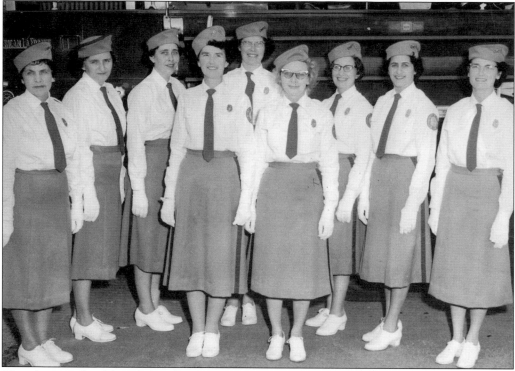

This photograph of the Clark Mills Women's Auxiliary shows the dedicated women who provided so much support to their community's volunteer fire departments. A similar group of women played an important role in the Clinton Fire Department. From left to right, they are Mary Newman, Betty Rehm, Beverly Ashley, June Perry, Ellen Buck, Eilliene Lomanto, Evelyn Spellman, Lou Acee, and Lois Hanrahan. (Courtesy of Cheri Misiak.)

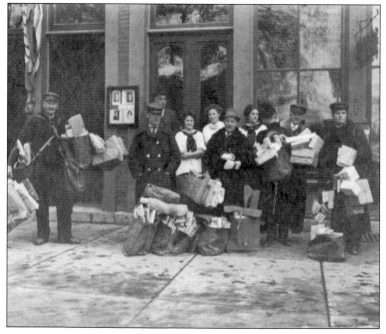

Taking a few moments from their hectic schedule delivering the December 1913 holiday mail, the staff and rural carriers pose for a photograph in front of the North Park Row Post Office. From left to right are postmaster F.E. Payne, his assistant F.M. Brockway, and office staff members Edna B. Schwartz and Camilla Payne with rural carriers C.R. Griffin, E.P Ellinwood, and L.H. Brockway. Also included are substitute carriers J.H. Libbey and A.D. Ward.

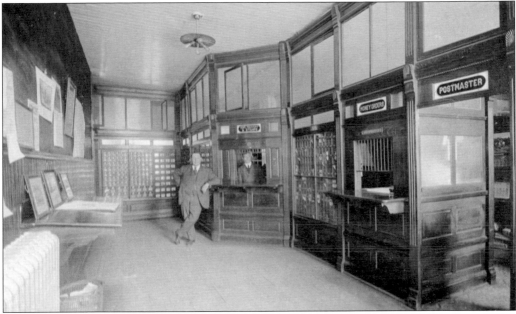

Postmaster O.J. Burns is seen with his assistant Gaylord Ward in the North Park Row Post Office in 1916. The North Park Row location was used from 1872 until 1926. An earlier post office was located on East Park Row.

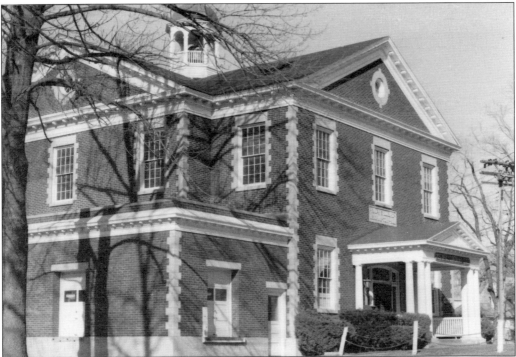

Local resident Ralph Lumbard's generous donation of $42,000 in 1926 allowed the construction of Lumbard Memorial Hall on the site of the former Park House Hotel. Designed by town architect Arthur Easingwood, it housed town and village offices, as well as the Clinton Post Office until 1989.

Although known more as an academic school in its early days, Clinton students were enthusiastic players. Pictured here is the 1902 basketball team.

Football teams from Clark Mills during the mid-1930s enjoyed many winning seasons. Note the shape of the early football and the lack of pads. (Courtesy Clark Mills Historical Society.)

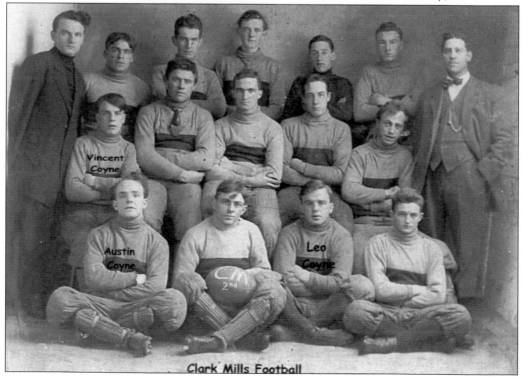

Clark Mills Football

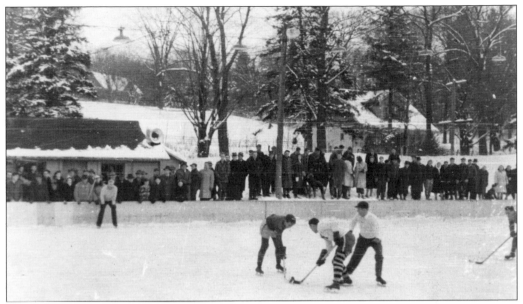

The arrival of A.J. Prettyman as the new athletic director at Hamilton College was instrumental in Clinton becoming a Hockeytown. Soon, young and old were doing their best on ponds and frozen waterways throughout the town. Eventually, this outdoor ice rink was created on the intersection of Meadow Street and Franklin Avenue. The Clinton Hockey Club won this early game against Massena. Pictured are referee Jim Shermin and players Fran Vonas, Rob Williams, Art Scoones, and Ed Bates.

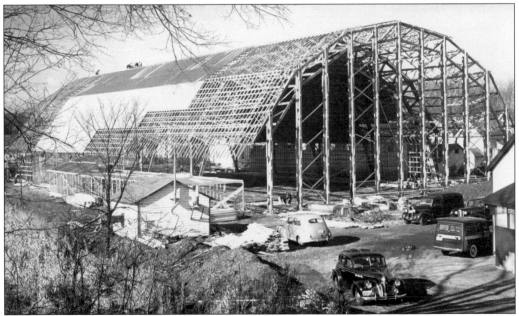

Due to the popularity of ice-skating and very successful hockey and figure-skating clubs, construction began on a state-of-the-art arena, unheard of for such a modest community, in 1948. There were numerous townspeople involved, and recognition must be given to Edward Stanley, a Hamilton College graduate and local businessman who organized and directed the first Clinton town team in 1928.

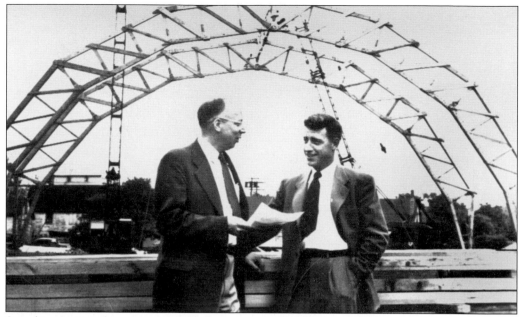

Standing against the structure of the first arena are Ed Stanley, also known as "Mr. Hockey," and outstanding player Greg Batt, who played for Hamilton College under Coach Prettyman and, later, professionally. He returned to Clinton as the coach at Hamilton for many years. Stanley was one of the most distinguished names in hockey, serving in a number of positions such as the US Olympic hockey committee and as manager of the successful Clinton Comets.

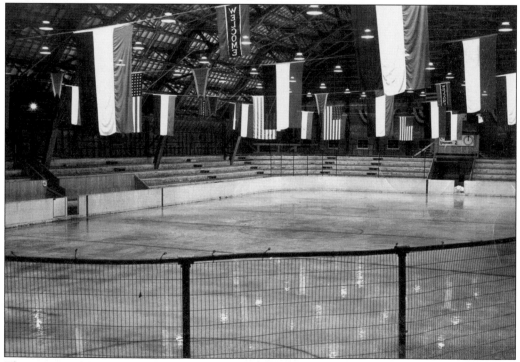

The interior of the original Clinton Arena is shown as it appeared in 1949. A marvel of engineering, it featured surface ice greater than that of Madison Square Garden.

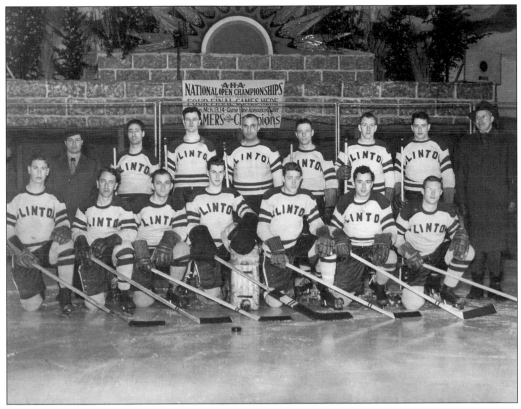

This photograph features the award-winning Clinton Comets hockey team.

After a devastating fire in September 1951 destroyed the original arena after a sold-out wrestling match, the townspeople immediately descended on the destroyed arena, moving rubble while it was still smoldering. The local campaign A Dollar Today for an Arena Tomorrow raised enough revenue to rebuild an even better arena a year later.

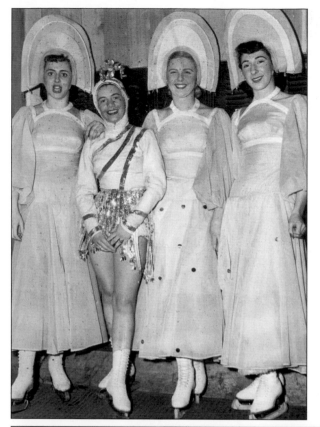

Figure skating has long been a fun activity; the Clinton Figure Skating Club presented incredible annual ice shows using the popular Clinton Arena.

Most children in the Town of Kirkland learn to skate early and extremely well, as evidenced by this 1950s photograph of Carlton Evans jumping a long line of barrels.

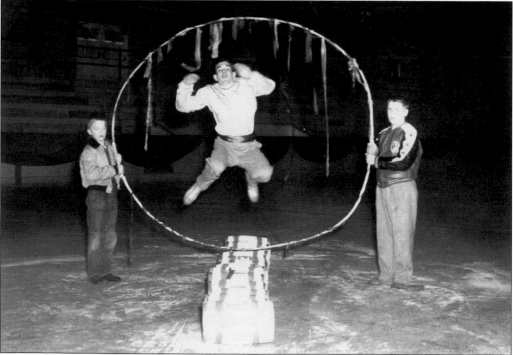

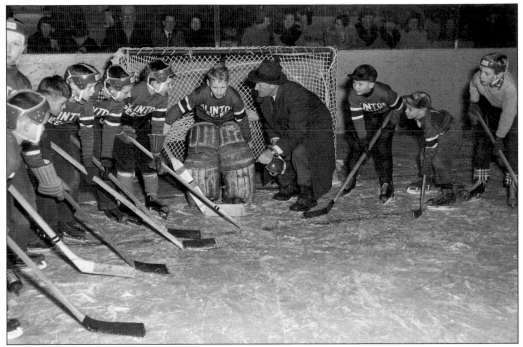

Wilfred "Red" Goering, the first goalie of the earliest Clinton school hockey team, went on to distinguish himself at Middlebury College and as a goalie for the first Clinton Comets team. Goering is seen here instructing young peewee-level players. His son, Gil Goering, played forward on the high school team and defense for Brown University. Both Gil and his grandfather served as Clinton's mayor.

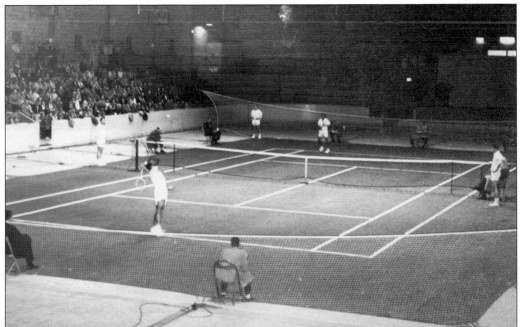

Ever since it was built, the arena has been used for a wide variety of community events, such as this tennis match.

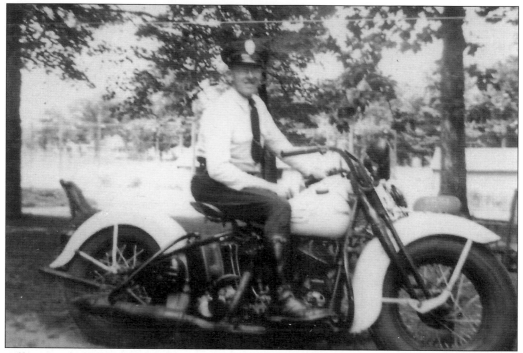

Officer Marlo Gilbert, highly respected as one of the very first police officers of the town, was a compassionate yet very capable and effective enforcer of the law. Officer Gilbert was famous for his skills with his trusty motorcycle. He received the first village police car in 1948. The village police department later merged with the Town of Kirkland Police Department to provide local and personalized police protection to town residents. (Courtesy of Marlene Gilbert Miner.)

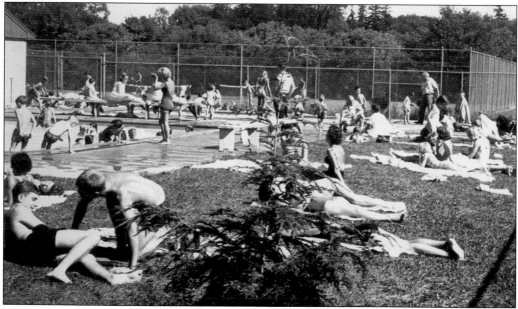

The community pool opened in 1957 and is named in honor of longtime *Clinton Courier* newspaper editor Jack Boynton, who helped persuade his fellow townspeople of its value. It remains the site for cooling relief and aquatic sports for people of all ages. Pictured here is the start of a swim meet.

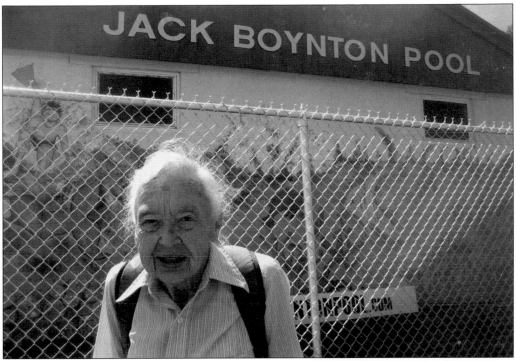

The children and families of Clinton's Jack Boynton Pool owe a great deal to the hard work and vision of Ibby Chicoquoine, whose dedication has not only kept the pool open for public use but has spearheaded a number of major improvements. (Courtesy of Frank Cittadino.)

The successful Kirkland Art Center grew out of popular evening art courses taught by artist/teacher Howard Chaney, whose vision brought about its current home in the former Methodist church on East Park Row in 1966. A major cultural provider for the region, it provides a wide array of arts-related classes, exhibitions, and performances.

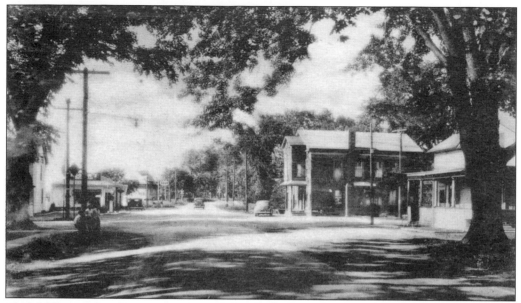

Clark Mills was a bustling community with hundreds of new families arriving during the late 1800s and early 1900s. So many newcomers arrived from England it was said that if one closed his eyes and listened to the conversations on the streets, he would think he was in London. (Courtesy of Clark Mills Historical Society.)

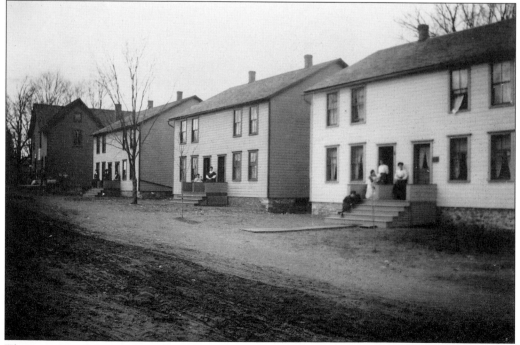

The majority of the sturdy and spacious factory homes built in Clark Mills has been extensively renovated and beautifully maintained. (Courtesy of Clark Mills Historical Society.)

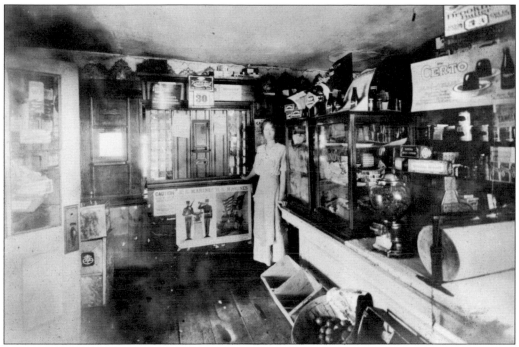

A popular spot in the hamlet of Kirkland was the combination general store and post office owned by Grace Woolmough Wood, pictured on August 30, 1921. Wood was also the postmistress.

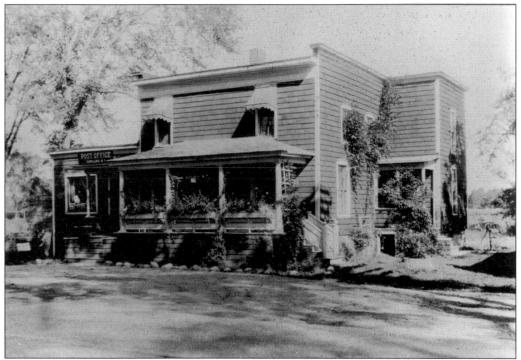

This photograph is of the Kirkland Post Office, which was located on Seneca Turnpike. The current hamlet of Kirkland was originally named Manchester, an indication of its early residents' strong connection to England.

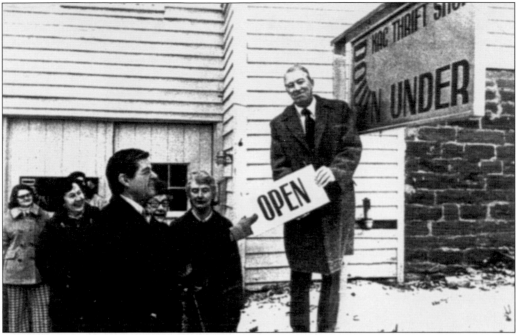

Kirkland Art Center (KAC) founder Howard Chaney and volunteers celebrate the opening of the Down Under Shop with longtime mayor Harlan Lewis. Established by volunteers during the early 1970s, it was a located where the Clinton Florist operates on Kellogg Street under the White Building and provided funding for the Kirkland Art Center until 2010.

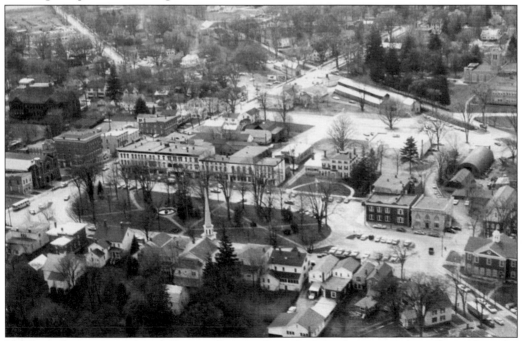

This aerial view from the 1960s reveals a number of subtle changes in the village. Note the coal sheds along the east side of Chenango Avenue and the number of structures north of the Chenango Canal.

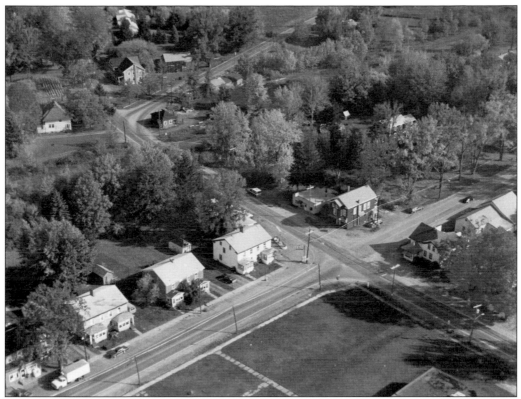

A modern-day aerial view of Clark Mills shows the beautiful tree-lined streets of the community today. Note the grassy park where one of the main buildings of the sprawling Hind & Harrison Company once stood.

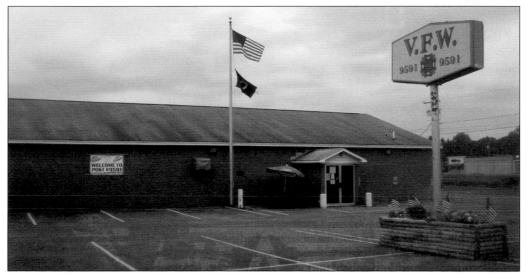

The VFW, located on Franklin Avenue, hosts and provides a number of community-related events and offers spacious dining facilities for veterans and their families.

One of the earliest cemeteries in the region, the Old Burying Ground on Kirkland Avenue contains over 500 graves of early settlers, including 47 Revolutionary War deaths, the largest number west of Boston.

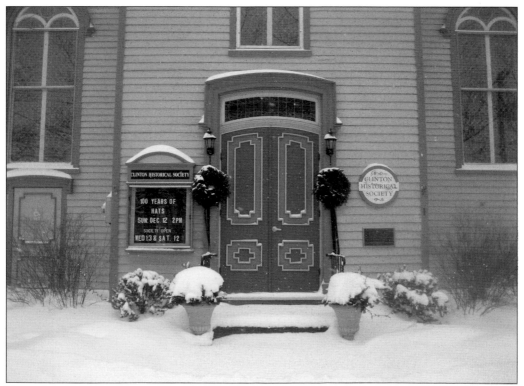

Formed in 1962, the Clinton Historical Society makes its home in the beautifully restored former Baptist church at 1 Fountain Street. Originally built in 1832, the building features a permanent museum of local artifacts, a research library, and history-based public programs for both adults and children. (Courtesy of Frank Cittadino.)

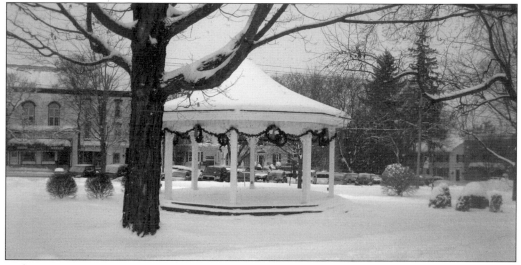

Perhaps even more beautiful during the winter after a gentle snow, the well-used gazebo serves a variety of community events from the traditional reading of Dickens's *The Christmas Carol* and holiday caroling to summer concerts in the park. (Courtesy of Frank Cittadino.)

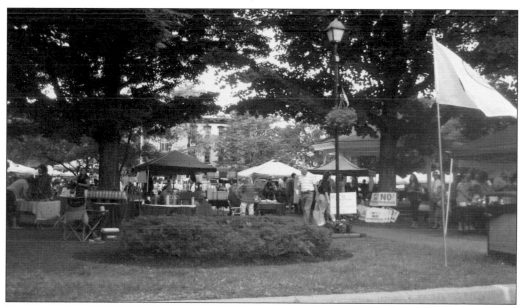

During the summer months, the Clinton Village Green hosts a robust farmer's market each Thursday offering foods and crafts. (Courtesy of Frank Cittadino.)

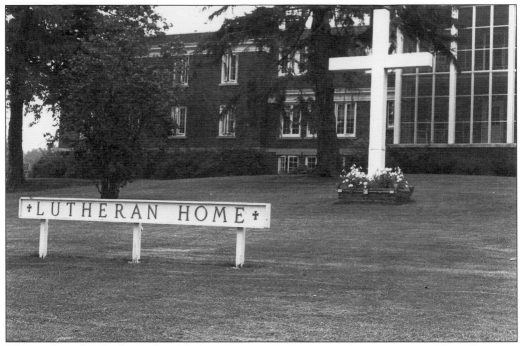

The modern-day LutheranCare Communities occupies a sprawling campus on Utica Street as well as several large properties throughout the town that offer varying degrees of independent living for older residents and those with various needs.

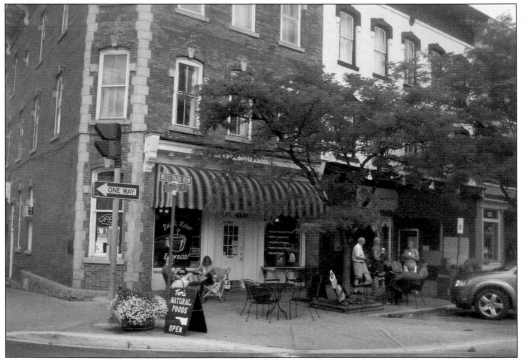

Not surprising, Hogan's Corner has remained a popular gathering place for residents and visitors for over 200 years. At the time of publication, it was occupied by Park Row Espresso.

Two

CHURCHES

On April 8, 1787, even before the early settlement was properly cleared for farming, religious services were held in the modest dwelling of Capt. Moses Foote, located at what is now the corner of West Park Row and College Street. On September 18, 1793, Rev. Asakel Strong Norton of Chatham, Connecticut, became the first pastor with meetings held in a log structure built on the Village Green. Construction of a proper church began in that location in 1795 and was completed in 1801. This drawing illustrates the new structure, affectionately known as the Old White Meeting House, which was used until 1836.

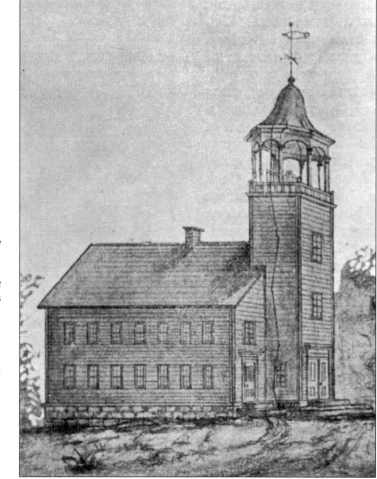

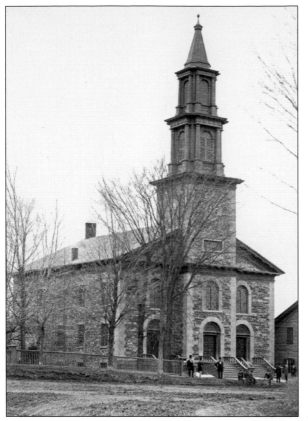

Although there were differences of opinion as to whether the Old White Meeting House should be repaired or not, a $1,000 gift by local merchant Orin Gridley helped the Society of Clinton to make the decision to construct a new church. Requiring two years and $8,000, this new structure was ready for formal services in 1836. The old meetinghouse was sold for $175.

After a number of years, the first Stone Church was erected by the Society of Clinton at a cost of about $8,000. It required two years to complete and was ready for services in 1836. Unfortunately, a fire that began on July 10, 1875, in a nearby shanty used as a tavern spread to the church, destroying it and the adjacent building shown in this photograph.

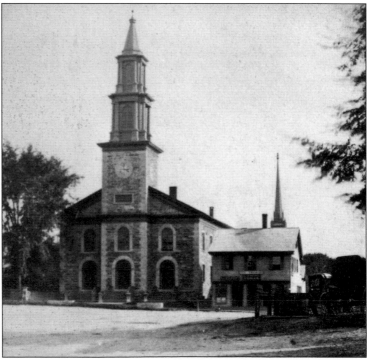

The cornerstone of the new Stone Church was laid on May 31, 1877, and the church was dedicated on February 14, 1878. This 1906 photograph of the new Stone Church shows its size and location closer to Williams Street. In 1923, it was determined that the steeple of the new church was unsafe, and work began to remove it. Note the new Kennedy Block on the east side.

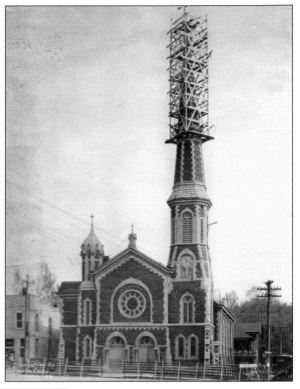

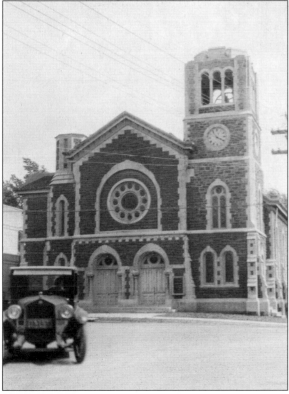

By the 1930s, the Stone Church appeared much as it does today. In 2009, its 1888 Seth Thomas eight-day clock, kept in perfect working condition by village employees, was replaced by a modern electrical clock when the original was moved to the Clinton Historical Society.

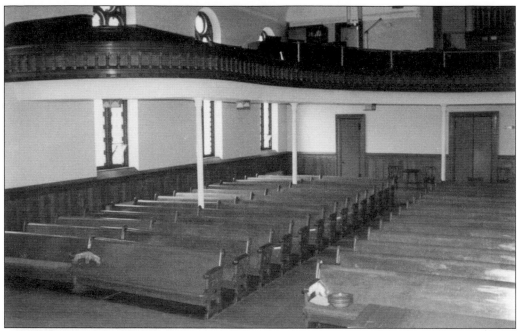

This view shows the interior of the Stone Church with its sweeping choir loft.

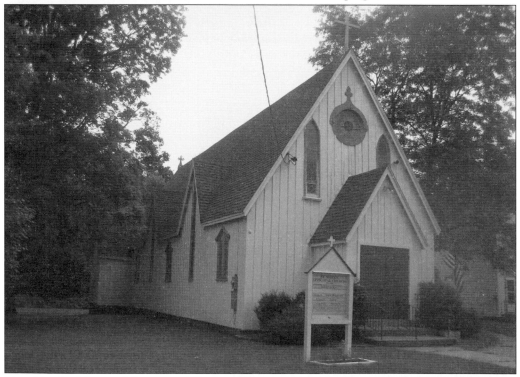

Listed in the National Register of Historic Places, St. Mark's Episcopal Church in Clark Mills is a beautiful example of board-and-batten construction in the Gothic style. Featuring windows stenciled to emulate stained glass, it was the first church constructed in Clark Mills in 1863 by J.O. Kinney on land donated by the A.B. Clark Company.

The Clinton Baptist Church was constructed at 1 Fountain Street in 1832 by Louis Wood at a cost of $2,000. A former blacksmith shop was previously located at this site.

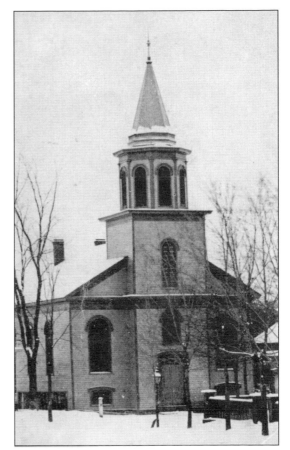

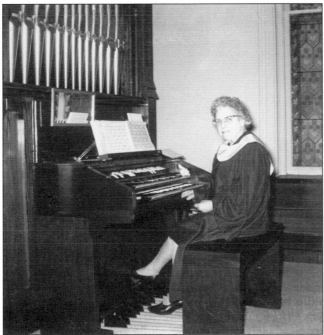

The organ of the Baptist church at 1 Fountain Street played an essential role in all church services. The beautiful brass pipes are still located on the east wall of the carefully restored building, which is now the home of the Clinton Historical Society.

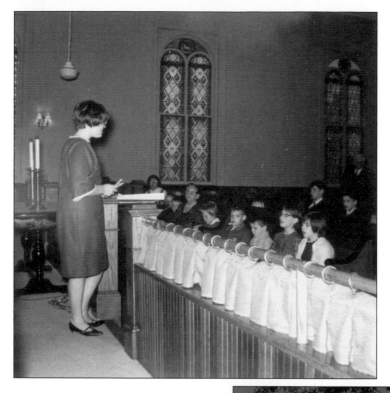

A Sunday school class was taught at the Baptist church. The original table seen holding the candles and pulpit are preserved in the permanent collection of the Clinton Historical Society.

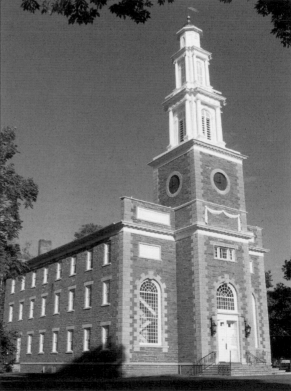

A landmark in the night sky and a beautiful icon of the campus, the Hamilton College Chapel began construction in 1825 to be completed in 1827. Its tower and steeple facade were designed by noted early American architect Philip Hooker, while the main structure was designed by trustee and Utica resident John Lothrop. Although not certain, it is believed to be the only surviving three-story chapel in the United States.

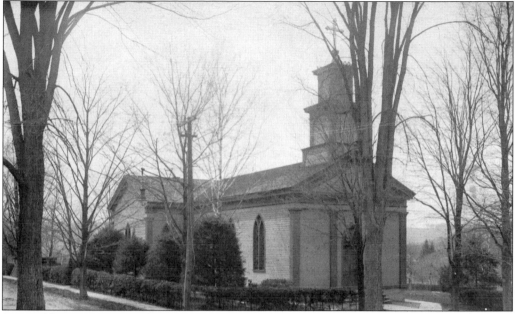

Inspired by many new residents arriving from Ireland, the original St. Mary's Roman Catholic Church was constructed of wood in 1851 on upper Marvin Street.

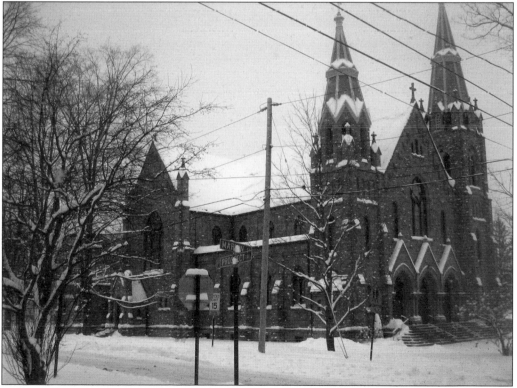

Built on the very same site as the original church, the new St. Mary's was of neo-Gothic design and made of reddish-brown sandstone. Here, it is shown caressed by a gently falling snow about to greet parishioners for mass.

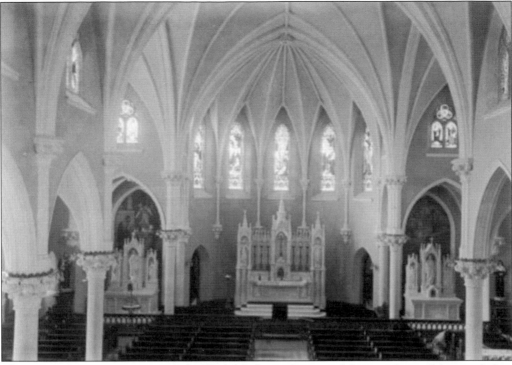

The new St. Mary's interior is a light-filled delight, with some of the most beautiful stained glass windows imported from Germany and gleaming white Italian marble altars.

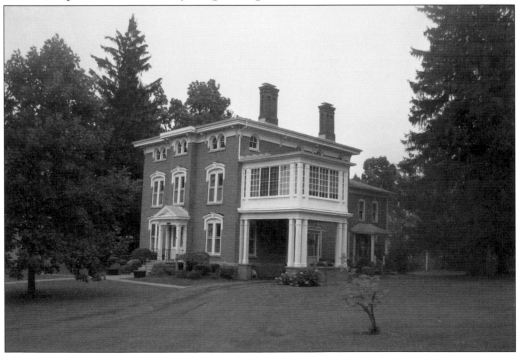

The rectory of St. Mary's, located across Marvin Street from the church, is an excellent example of the Italianate style.

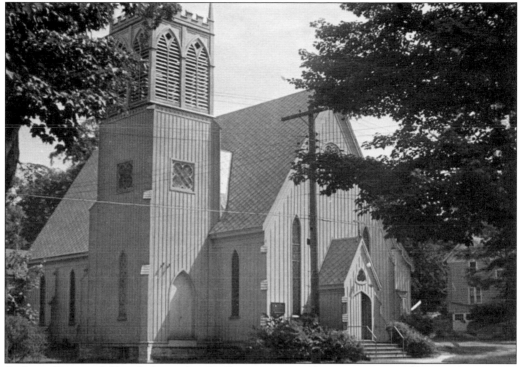

St. James Episcopal Church, located on Williams Street in Clinton, was inspired by noted American architect Richard Upjohn. It was dedicated in 1865 with a rectory built from architectural designs by William Ranlett. Unfortunately, the steeple of this Gothic Revival church was destroyed by high winds in 1893.

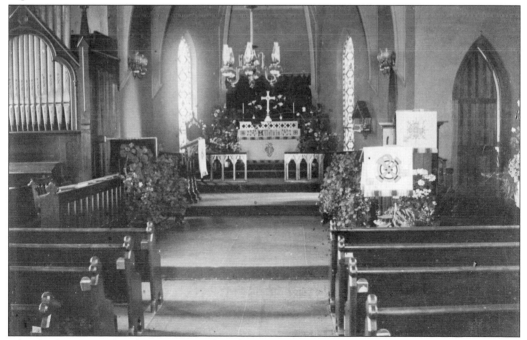

The Gothic Revival style is continued in the charming interior of St. James Episcopal Church.

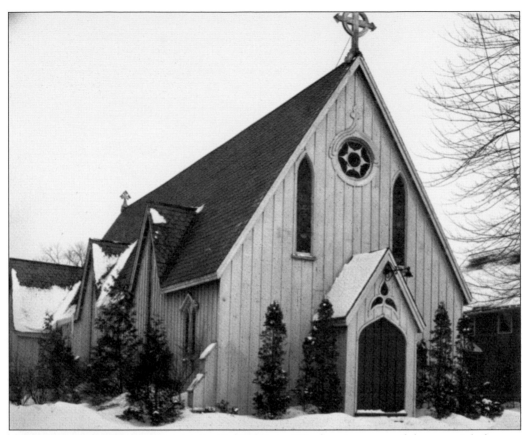

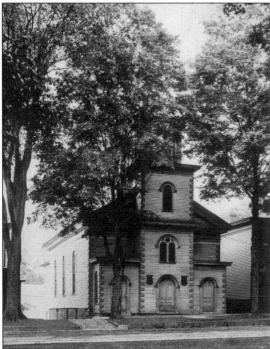

Wisely using some of the materials from the Old White Seminary, many Clark Mills residents, both Catholic and non-Catholic alike, helped to build the new Church of the Annunciation. Fr. James O'Reilly celebrated its first mass on Sunday, May 8, 1910.

The original Methodist church was located on East Park Row. Built in 1842 at a cost of $2,500 advanced by church founder Walter Gillespie, it served the community until the congregation built a new structure on Utica Street. The congregation moved into its new church on Sunday, May 1, 1966, and the original building is now home to the Kirkland Art Center.

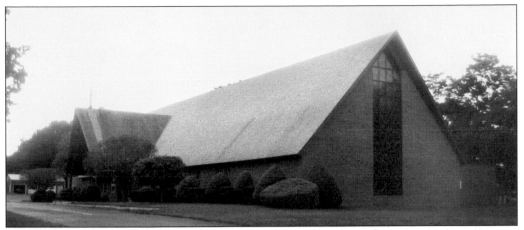

The current Methodist church is a more modern structure located just outside the village on Utica Street.

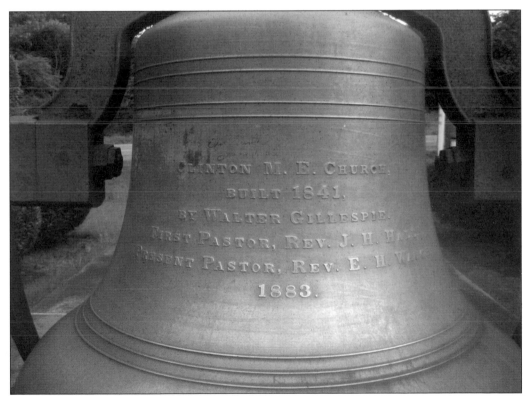

The bell removed from the original church sits in an area of decorative plantings in the front of the new church on Utica Street.

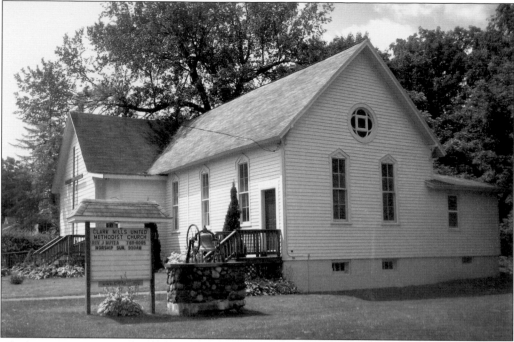

The beautifully proportioned Clark Mills United Methodist Church is located on Clinton Street in Clark Mills.

This well-maintained residence on Utica Street in the Village of Clinton was once the site of the early Universalist church.

Three

SCHOOLTOWN

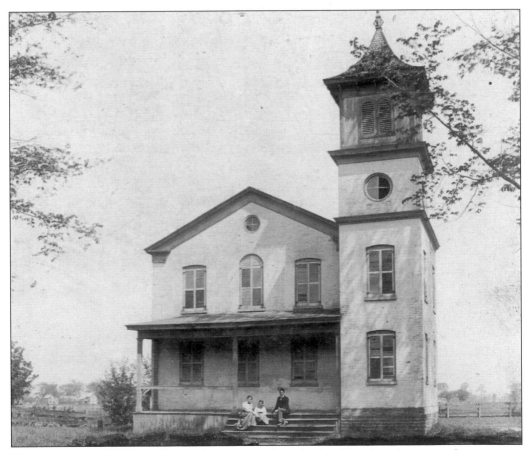

Community members saw the need to create a formal school for the education of community children and established the Clinton Grammar School in the vicinity of 96 College Street. It was attended by a number of young Clintonians, including Elihu Root and Grover Cleveland.

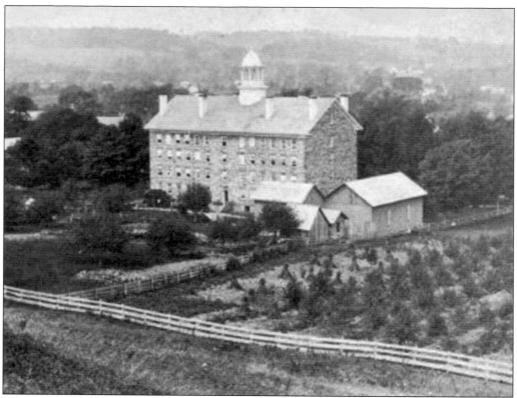

Located on College Street during its first year, the Male Division of the Clinton Liberal Institute moved to this new building at the corner of Utica and Mulberry Streets in 1832. Among its illustrious students was the founder of Stanford University, Leland Stanford.

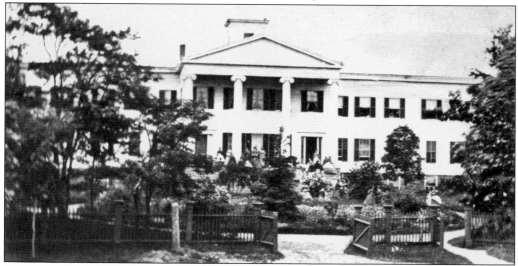

Constructed in 1850 at 13 Chestnut Street as the Female Division of the Clinton Liberal Institute, the Old White Seminary was a large wood structure measuring 144 feet across the front and 60 feet deep. A prestigious early American school, it was proud to claim Clara Barton, founder of the American Red Cross, as one of its alumni. After the Clinton Liberal Institute closed, a private residence designed by Edwin Torrey was built on the site using the original columns.

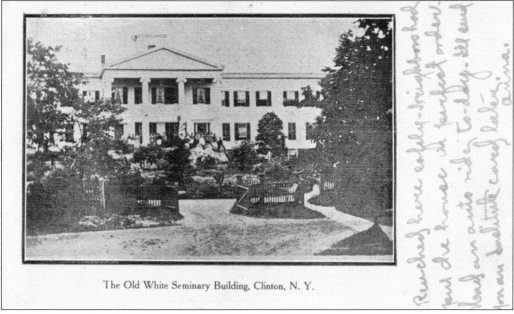

The Old White Seminary Building, Clinton, N. Y.

An early postcard of the Old White Seminary contains a note indicating that the author arrived safely via an automobile.

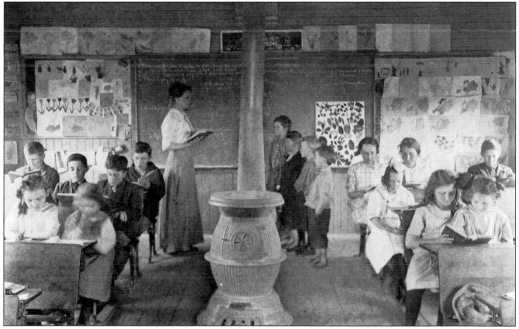

Before the school centralization movement of the 1930s, the town was dotted with one-room schools. This rare photograph is believed to be of the interior of the small school located in an area the local residents called "London," located on Skyline Drive just past Hamilton College.

53

Morilla Houghton Gallup and her husband, Dr. John Chester Gallup, purchased the Cottage Home Seminary in 1861 from its founder, Louisa Barker. They changed the name to Houghton Seminary and operated the prestigious school until 1880, when it was purchased by Prof. A.G. Benedict. The site at the far western end of Chestnut Street is currently a private residence.

HOUGHTON SEMINARY.

This Certifies, That

Sarah Gardner,

has completed the prescribed Course of Study at Houghton Seminary, and by her attainments and correct deportment is entitled to this Testimonial.

Given at Clinton, this twenty-third day of June, in the year of our Lord one thousand eight hundred and sixty-nine.

Principals.

Dr. and Mrs. Gallup purchased the Cottage Home Seminary in 1860 and renamed it the Houghton Academy, with about 50–60 young ladies and 12–15 young boys in attendance. This photograph is of an actual diploma from the Houghton Seminary awarded on June 3, 1869.

Louisa Barker's reason for selling the Cottage Home Seminary was to build an even smaller, more personalized school, which she had constructed on the site of the current Clinton Middle School on Chenango Avenue.

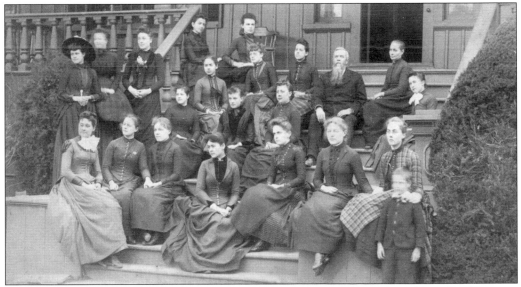

Located on the western side of present-day Chenango Avenue where the public school campus is, the Cottage Seminary was operated from 1861 until 1898 as a combination boarding and day school. In this 1887 photograph, students are gathered on the front steps with headmaster Rev. C.W. Hawley, his wife, Martha (Joqueth) Hawley, and their children. They purchased the school from Anna Chipman, who was associate principal to founder Louise Barker. Reverend Hawley was a graduate of Amherst College, and Mrs. Hawley was one of Anna Chipman's former teachers. They were married on June 12, 1872.

Post Card

The Fifth Annual Reunion of the Cottage Seminary Association will be held at the Seminary Building, Clinton, August 9, 1911.

Luncheon at 1 P. M.

Kindly respond by August 1st to (Miss) Edith V. Allen, Secretary, Clinton, N. Y.

Luncheon, 30 cents. Dues, 25 cents.

This postcard was used to summon alumni and supporters of the Cottage Seminary to their fifth reunion, to be held August 9, 1911.

The Clinton Seminary began as Kellogg's Young Ladies Domestic Seminary on the corner of Kellogg and Mulberry Streets. Requiring larger quarters, the school moved to a neighboring community in 1845. The building is now a private residence.

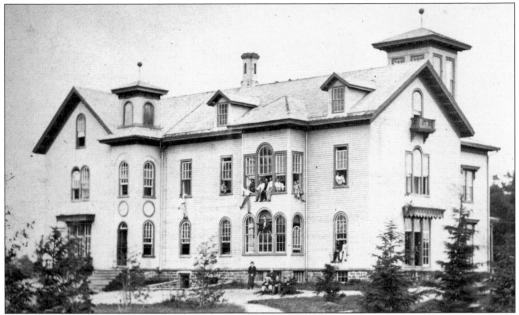

Rev. Benjamin Dwight opened a high school in 1858 at the corner of Elm Street and Norton Avenue; however, it was destroyed by fire in 1864. Once known for its exquisite landscaping, it is now the site of a number of private residences.

From 1814 to 1856, the Royce Academy operated as a boarding and day school for young ladies from across New York State and Canada, including several from the Native American community. Its last location was the former Royce Mansion on the northwest side of the Kirkland Avenue–Chenango Avenue intersection.

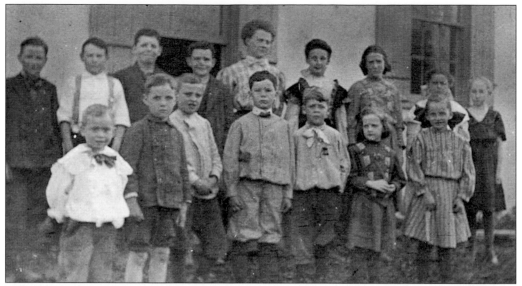

Throughout the 1800s and early 1900s, the more rural areas of the town were dotted with a variety of small schools. This 1909 image captured the children and teacher at the Dugway Road School. Reports in 1865 indicated that almost 1,500 school-age children lived in the town's 15 school districts. Prior to the New York State Compulsory School Law of 1894 requiring full-time school attendance for children 8 to 14 years of age, about half of all the town's school-age children actually attended school.

A major decision by the voters in Districts No. 4 and No. 5 authorized action to build a graded free school, resulting in the opening of the Clinton Union School and Academy on Marvin Street in September 1893. At a cost of $42,000, the new school of red brick and sandstone could accommodate about 600 students, with grades one through eight on the first floor and a full high school program on the second floor. Today, the building is the Marvin Street Apartment Building.

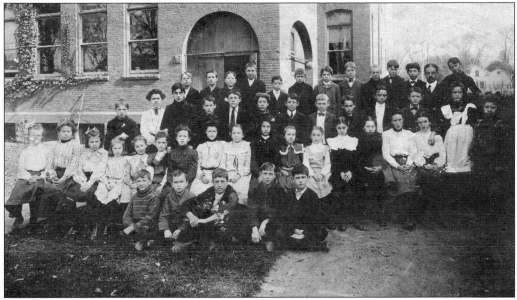

Members of the class of 1896 are pictured in front of the Marvin Street School. News of the school's quality instruction encouraged parents outside the district to pay tuition to have their children educated there.

Looking as ready to welcome students today as it did over 100 years ago, this well-maintained brick building on Old Bristol Road was originally constructed as one of the town's first one-room schools.

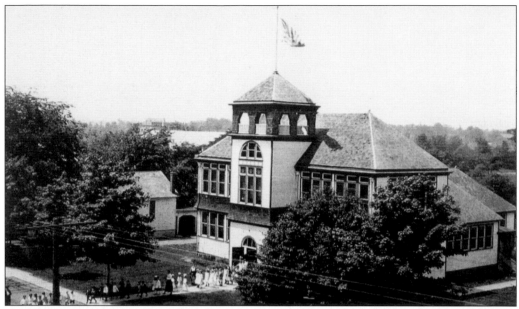

This photograph of the Clark Mills School was taken in the late 1800s, when the beautifully proportioned school offered kindergarten through 12th grade. It was located adjacent to the current Clark Mills American Legion in the pasture used for its annual field days. (Courtesy of the Clark Mills Historical Society.)

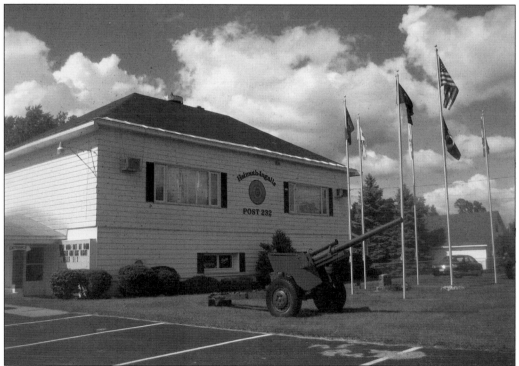

The American Legion Post No. 232 on Route 12B in Franklin Springs actually began life as the Franklin Springs (earlier known as Frankin Furnace) School during the early days of the hamlet, before the school centralization movement.

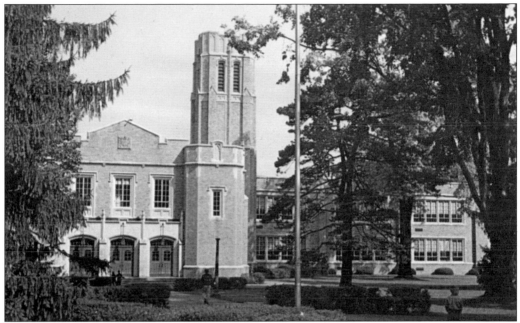

The school centralization movement of the 1930s and resulting consolidation of one-room schools brought about the construction of the Clinton Central School District's new high school. Built for a then staggering sum of $350,000, the state-of-the-art school opened in 1931 and housed grades seven through 12, while Marvin Street School served as the district's grammar school.

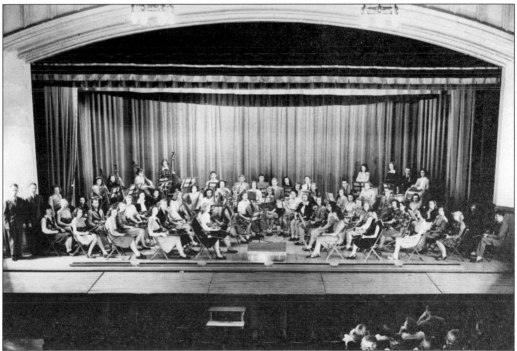

The high school has long been recognized for the quality of its academic and arts programs. This photograph was taken of the high school orchestra on the school's beautiful proscenium arched stage.

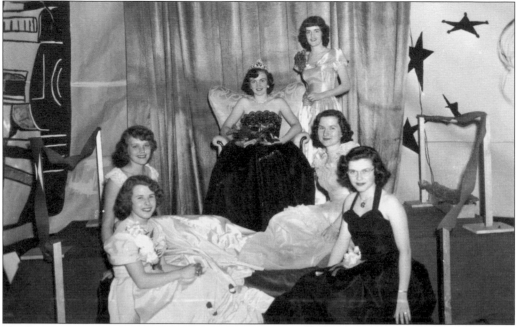

Shirley Nester was crowned queen of the class during a 1950s prom. The prom enjoyed a long tradition as a vehicle to encourage students to collaborate on the extensive building and decorating that transformed the high school gymnasium into a fantasy environment. Some contemporary changes to the Clinton prom included abandoning the selection of a queen and king.

Noted for quality schools since the early 1800s, the commitment to maintaining a quality educational program earned the Clinton Central School District the National School Recognition Award by the US Department of Education. Renovations and additions to the school complex continue to this day.

Four

HAMILTON COLLEGE

The Town of Kirkland is home to Hamilton College, the third college granted a charter in New York State and one of the oldest in the nation. Rev. Samuel Kirkland met with President Washington and other dignitaries to discuss his idea for a school. Among those in attendance was Alexander Hamilton, the first secretary of the US Treasury, who lent his name to the new school and agreed to be one of its trustees. It was chartered as the Hamilton-Oneida Academy in 1793. (Courtesy of Clarence Aldridge.)

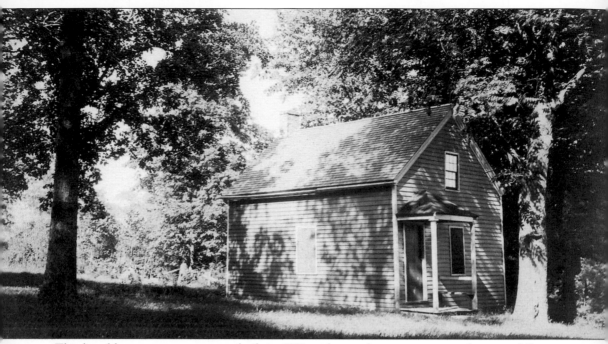

This humble one-room structure, built in 1790 with two sleeping rooms on the second floor, is affectionately called the Kirkland Cottage. It is the first substantial structure Samuel Kirkland, a visionary young missionary, built on his quest to construct a school to educate the Native American children and those of the early settlers. Originally situated at the foot of College Hill, it has been relocated to the Hamilton College campus. Each fall, entering freshmen are allowed to enter the cottage and sign their intent to be educated in the long tradition of one of America's most prestigious schools. (Courtesy of Hamilton College.)

The strong relationship based on friendship and mutual respect between Reverend Kirkland and the chief of the Oneida nation, Schenandoah, inspired the chief to request to be buried near his longtime friend in the college cemetery. (Courtesy of Faye Cittadino.)

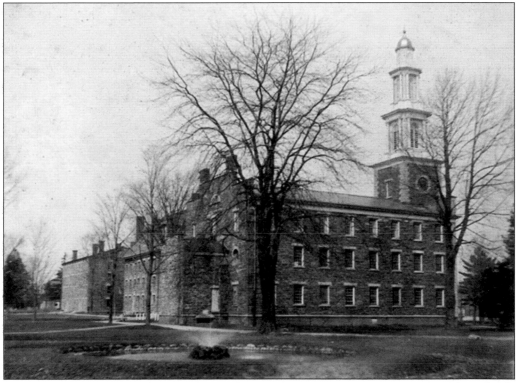

Realizing the importance of having a formal place of worship on campus, then-president Henry Davis and the trustees stopped work on the North Residence Hall in 1825 to build the college chapel. The steeple and tower facade were designed by noted architect Phillip Hooker, while the main part was designed by trustee John Lothrop, who lived in Utica. Believed to be one of the very few and perhaps the only surviving three-story chapel in the country, it is a true reassuring landmark set against the night sky with its illuminated steeple. (Courtesy of Hamilton College.)

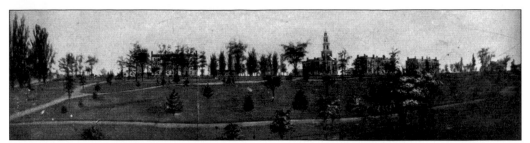

This is the believed to be the earliest known photograph of Hamilton College, taken around 1860.

Now situated on 1,350 acres upon a hill overlooking the picturesque Village of Clinton, pictured are the two stone columns of native limestone that greeted visitors to the entrance of the Hamilton College campus. Note the descent down the hill to the village—a walk early students would do daily.

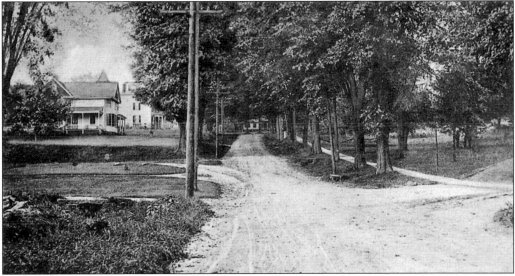

A photograph of Freshmen Hill from the mid-1800s shows the early layout of the ascent on College Street toward the campus. Note that Harding Road on the left and Bristol Road on the right are not directly across from one another as they are today.

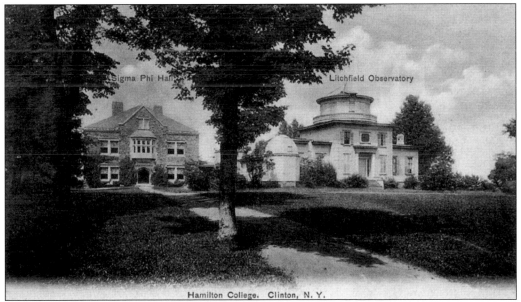

Hamilton has enjoyed a well-deserved reputation as one of the country's most demanding post-secondary institutions, attracting distinguished professors with an interest in teaching. Such was the case of professor of astronomy H.F. Peters, one of the most respected astronomers of his time, who founded the newly constructed Litchfield Observatory at Hamilton. The observatory boasted a 13.5-inch reflector telescope, one of the largest in America at that time. Over his career, he is reputed to have discovered over 12,000 asteroids.

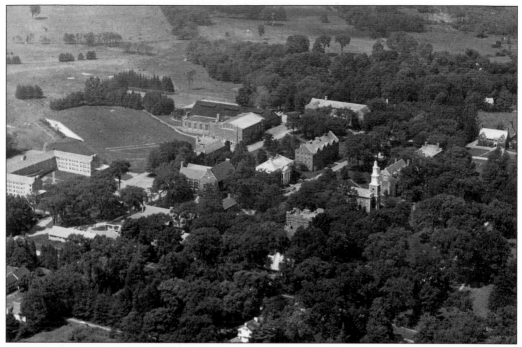

This aerial view of the beautifully landscaped Hamilton College campus was taken in 1963, just a few years before it established its sister institution, Kirkland College, in 1968. The two schools merged in 1978, making Hamilton College coeducational.

Buttrick Hall, built in 1812, was the birthplace of the Honorable Elihu Root. After a remodel changed the facade from two doors to one and added a complex roof of gables, as shown here, it was returned to its original design and serves as the office of the college president, currently Dr. Joan Hinde Stewart. (Courtesy of Hamilton College.)

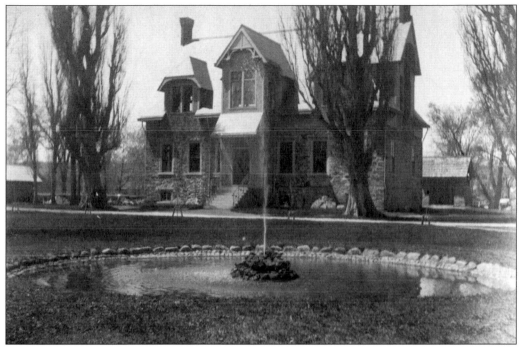

Elihu Root built Root Hall in 1897 as the Hall of Science to honor his father, Prof. Oren Root. He attended Hamilton College himself and later became a Nobel Prize laureate, distinguishing himself in many areas, including as the US secretary of war under presidents William McKinley and Theodore Roosevelt. In 1905, he was named US secretary of state.

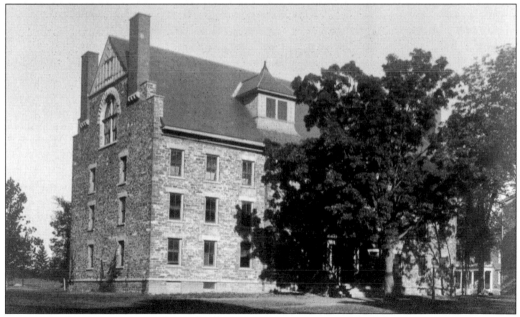

Currently the Kirkland Residence Hall, this structure was modified from the original Middle College building, erected in 1825, into Soper Gymnasium, which featured a basketball court using the third and fourth floors, a wood-floor running track, and a swimming pool in the basement. (Courtesy of Hamilton College.)

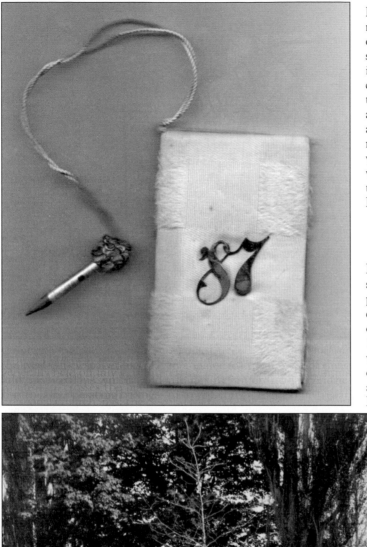

In 1887, college life was more than just studying, even at a rigorous school such as Hamilton. Featured in this photograph is a dance card presented to the young ladies when they attended a formal dance at Hamilton. It served to record the names of the young men they danced with and the type of dance they enjoyed. (Courtesy of Hamilton College.)

Hamilton students are seen relaxing in this 1873 photograph. The modern-day student body at the competitive school is at 1,812 students as of this writing, with an almost equal division of women and men. (Courtesy of Hamilton College.)

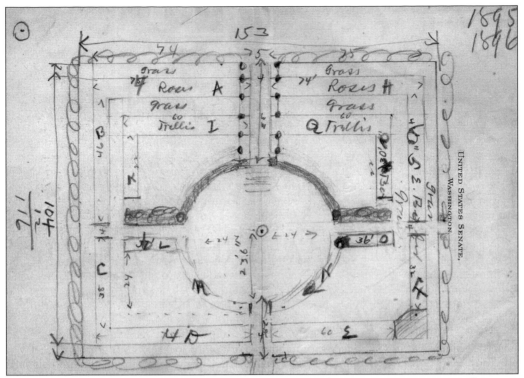

This early drawing, created by the Honorable Elihu Root when he was a US senator, illustrates his dream for expanding the gardens developed by his parents on the Root family homestead to eventually become the very popular Root Glen. Now containing over 65 species of trees and scores of different shrubs and flowers, it is the result of three generations of Root family dedication. (Courtesy of Hamilton College.)

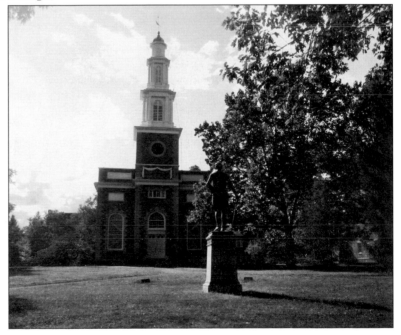

A bronze statue of Alexander Hamilton with a beautiful green patina faces the chapel and the earliest buildings of the original campus. During the 19th century, students were expected to meet each morning in the chapel to hear a lesson, usually from the president. (Courtesy of Faye Cittadino.)

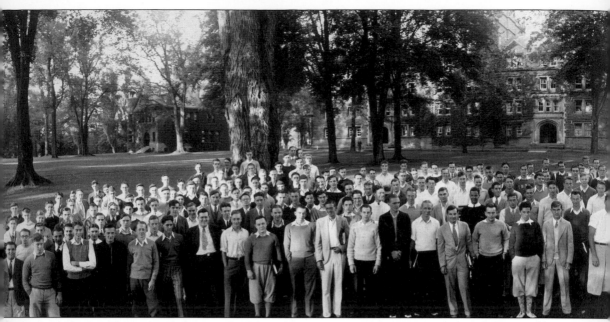

By the time this unusual photograph of the entire student body was taken in 1931, Hamilton College
had attained a solid reputation as one of America's more prestigious liberal arts institutions. After

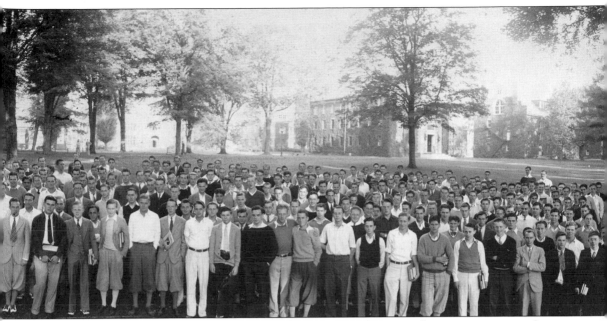

its beginning as a small regional school on the American frontier, it began attracting students from across the United States. (Courtesy of Hamilton College.)

A women's college to complement the all-male Hamilton College opened in the fall of 1968 on a brand-new campus adjacent to Hamilton. It operated until 1978, when financial considerations made it necessary for the women's college to be absorbed by Hamilton, making Hamilton College a coeducational institution and synthesizing the best ideas of both institutions. The Kirkland side of the campus features more modern architecture and the college's art and music departments, including the Schambach Center for Music and the Performing Arts. Like the original Hamilton campus, it has seen tremendous growth.

During the 1900s, the trip up to the college was by either horse or foot. The dirt road that was College Street had several areas where local farmers could pull off to rest their horses. Underclassmen were boarded in the town, with many walking up and down the hill several times a day. To help their arduous journey, the sidewalk was covered with wood and a resting stop was provided with this stone arbor, which replaced an even earlier wood structure. The stone arbor was dedicated in memory of Newton Beach Jr., class of 1894.

Five

BUSINESSES

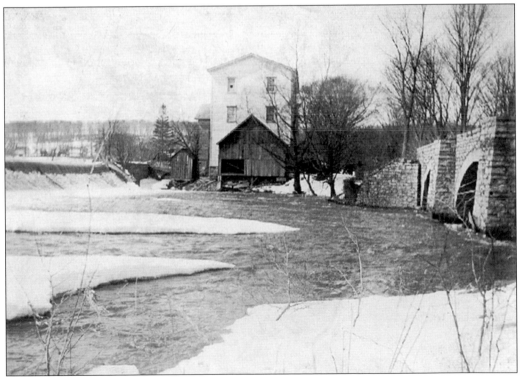

One of the very first businesses created in the early settlement was a gristmill built by Captain Cassety in the fall of 1787. Located on the east side of the Oriskany Creek where it crosses present-day College Street, it was the site for many subsequent gristmills that ground feed for livestock as well as flours named White Silk and Snowflake.

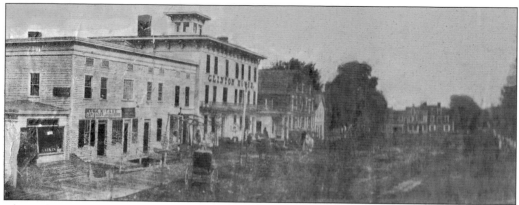

The earliest known photograph of West Park Row shows very early businesses such as the Clinton Hotel and Hugh McCabe's dry goods and grocery store.

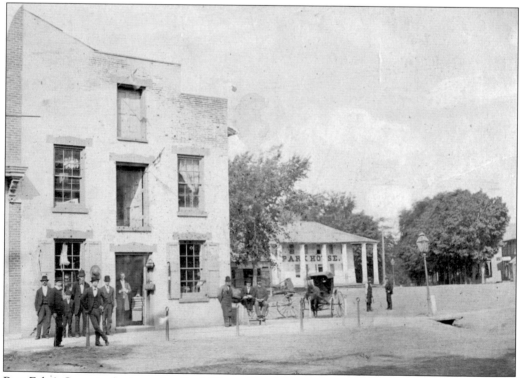

Past Fake's Store is the imposing Park House Hotel, located on the site of the current Lumbard Memorial Hall. Built originally as the Tavern in 1800 by Deacon Isaac Williams, it was the site for the first meeting of the newly chartered Hamilton College's board of trustees in 1812.

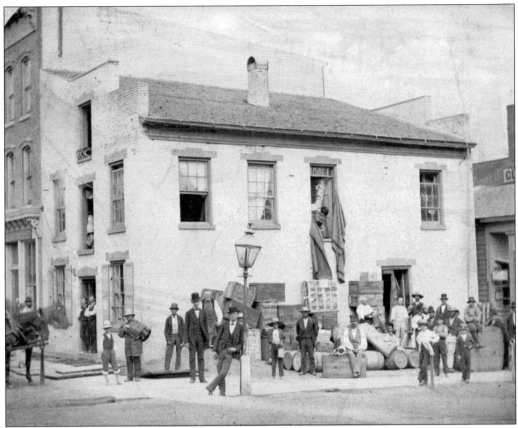

Reportedly the most honest businessmen one could hope for, Peter Fake and his son Augustus had a store here in a building originally constructed by Amaziah Stebbins on the site of current Firehouse No. 1.

Recognized as one of the earliest signed pieces of pottery in the country, this beautiful earthenware plate was created by Clinton potter John Betts-Gregory. Gregory came to Clinton in 1814 with his wife and two daughters and purchased the pottery behind the current Owens-Pavlot Funeral Home from Erastus Barnes, Clinton's first potter.

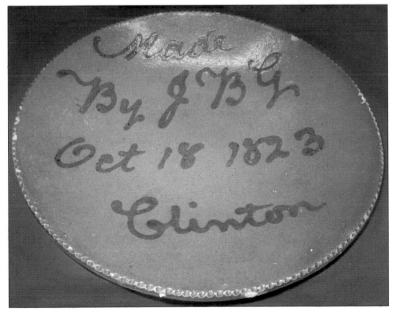

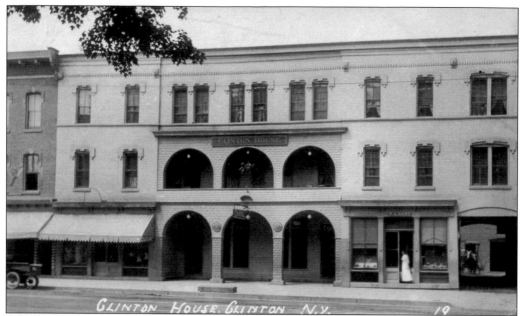

Originally on the site of an earlier hotel built by Judah Stebbins in 1805, Stebbins Tavern on the Green was destroyed by a devastating fire in 1872. It was then purchased for $5,300 by local harness maker Col. John Tower, who built it into a three-story, state-of-the-art hotel complete with a grand winding staircase leading to an upper dining room. It is the current location of Nola's Restaurant.

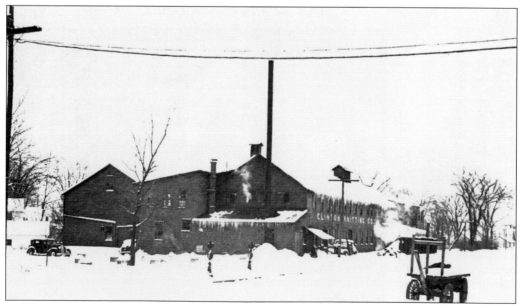

Located where the Clinton House Apartments are today, the Clinton Knitting Mill became the largest manufacturer of wool bathing suits in the country.

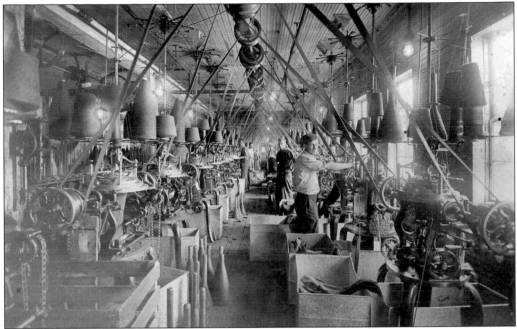

Although not a major part of the town's economy, the mill provided employment for residents from its opening in 1810 (originally as a cotton mill) until it was completely destroyed by fire in 1891.

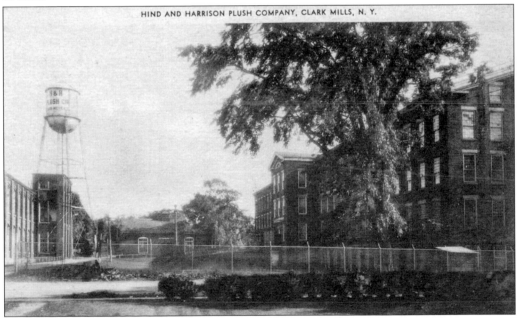

The huge Hind & Harrison Plush Company moved into factory buildings originally constructed by Erza Clark, an early settler of Clark Mills, in 1790. His three sons, Ammi, Eneas, and Ralph, created a successful cotton-manufacturing facility. Arthur Hind and his partner, Herbert B. Harrison, expanded the facility and added a new factory to the complex, making it able to run over 225 looms and produce over two million yards of product per year. (Courtesy of the Clark Mills Historical Society.)

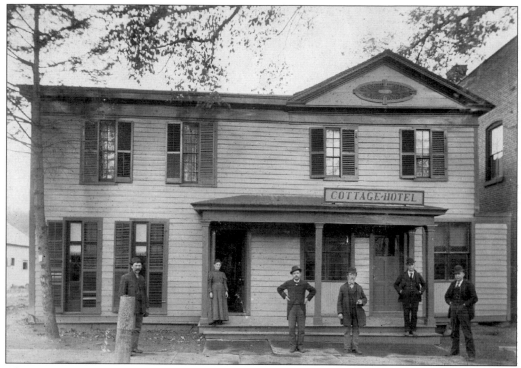

The Cottage Hotel, once located on the site of the current village parking lot on College Street, was later known as Dempsey's Tavern until it was torn down in 1959.

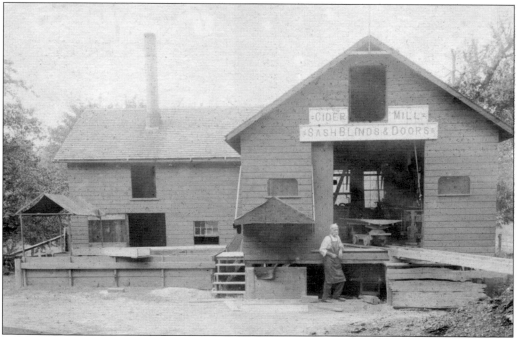

Early craftspeople opened businesses throughout the growing community during the mid-1800s, such as William H. Toomer's successful window and door business on Mulberry Street. He also ran a cider mill at this location during the fall harvest.

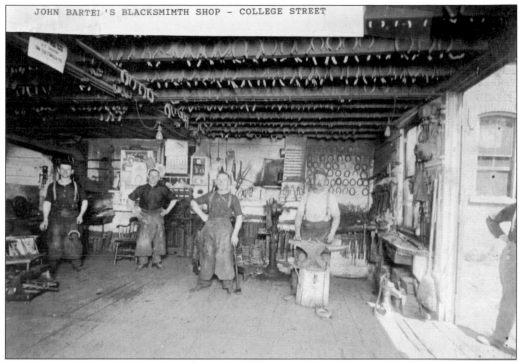

With transportation centering on horses, it was unusual for John Bartel and his crew to take a break for this photograph. Bartel was one of several blacksmiths and harness makers.

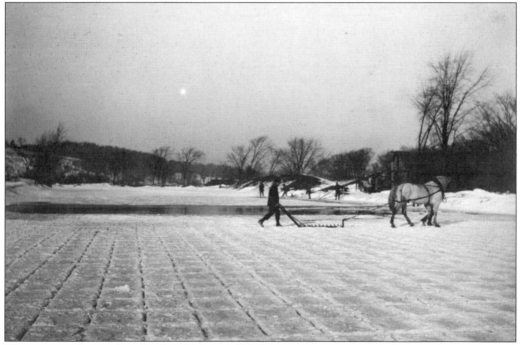

The man-made pond at the Franklin Iron Works saw many uses, including as a source for the precious blocks of ice used to keep foodstuffs cool in the kitchens of townspeople throughout the year.

The unusual shape of this village landmark was dictated by both the railroad and the nearby Chenango Canal. It has provided camaraderie and beverages for decades and is believed to be the oldest continually operating tavern in the area.

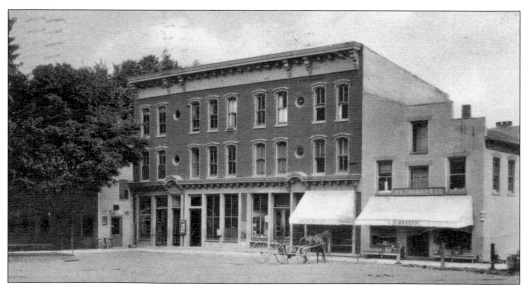

Constructed in 1869, the Sherman Block housed many early businesses at its North Park Row location, including the post office from 1872 to 1926. Unfortunately, a devastating fire destroyed the block on July 4, 1989. This photograph was taken before the construction of Firehouse No. 1. The new block constructed after the fire houses law offices, engineering, and other businesses.

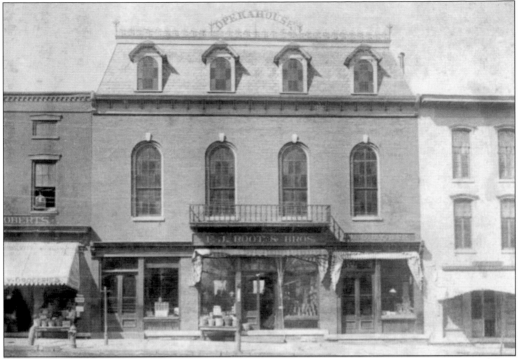

Local physician Dr. James Scollard purchased the Tower Block in 1876. After extensive remodeling in 1885 that included a new mansard roof complete with ornamental iron work incorporating the words "Opera House," it became the site for many community events from basketball games, silent and later talking movies, dances, and meetings. It was constructed to allow for easy access from the elegant Clinton House Restaurant so patrons could stay warm and dry as they attended an event after dinner. The building has essentially kept its original appearance, although the upper floor with its 20-plus-foot-high ceilings has been converted to accommodate two floors of apartments with views of the historic Village Green.

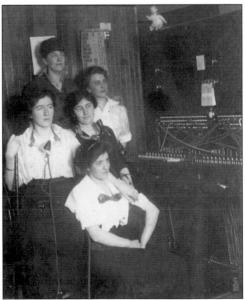

In July 1905, the Clinton Home Telephone Company moved its telephone exchange to a new building on Williams Street constructed by Stanley Powell. It had been incorporated just a few months earlier on March 27 with G.J. Cauldwell as president. Dial service came to Clinton in 1957 when the New York Telephone Company erected a new structure on Kirkland Avenue adjacent to the Old Burying Ground.

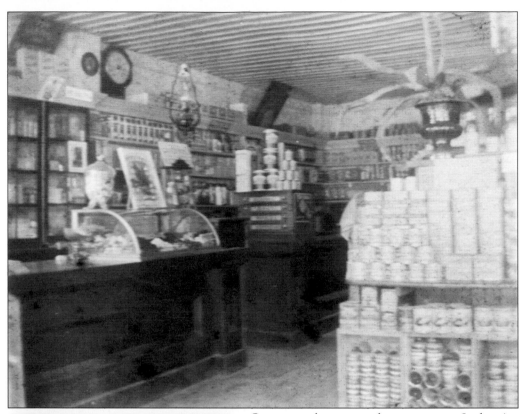

One can only imagine the opportunity Latham's Store provided for local residents to converse with friends and neighbors while benefitting from the well-stocked inventory.

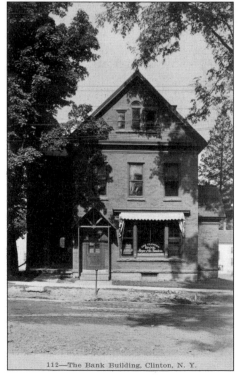

112—The Bank Building, Clinton, N. Y.

This wood-frame building at 1 Water Street was originally the home of Dr. Seth and Eunice (Parmele) Hastings and their 15 children. Seth and Eunice Hastings were married on November 6, 1799, in Washington, Connecticut. It later housed the Clinton Bank, which was transferred to Hayes and Company in 1878 and eventually became the Hayes National Bank. It is currently the site of NBT Bank.

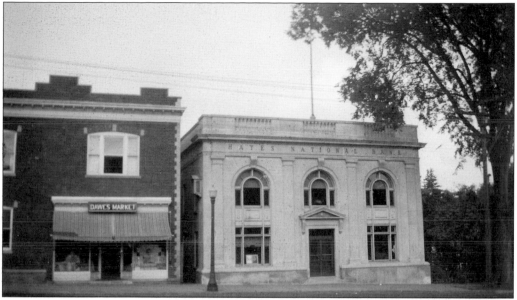

Opening for business on Easter Monday, 1897, the Clinton Bank became the Hayes National Bank in December 1912. In 1927, the original wood building was reconstructed with a concrete facade to appear very much as it does today as a branch of NBT Bank. This view also shows the Dawes Meat Market, which occupied a small wooden structure between the new firehouse and the bank. The meat market was removed when it became necessary to enlarge the firehouse.

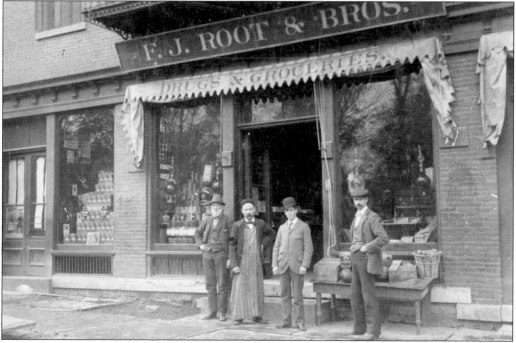

The Root Store was operated by the Root brothers, who purchased it from William Raymond in 1886. They offered a variety of items, including schoolbooks, until 1917, when the brothers sold it to J.W. Delahunt. He continued to operate the business until the Victory grocery store chain moved in during 1951.

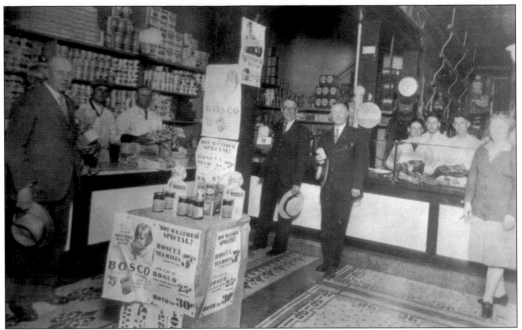

Customers and staff pose for this 1925 photograph in J.W. Delahunt's well-stocked grocery store. Note the "hot weather special" featuring a jar of Bosco's tea balls for 25¢ or an individual ball for a nickel.

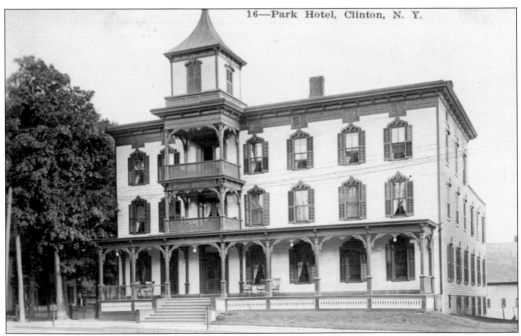

Originally the private residence of the Deacon Orin Gridley family until the 1880s, this stately home on South Park Row became the Willard House and was considered one of the finest hotels in the upstate region.

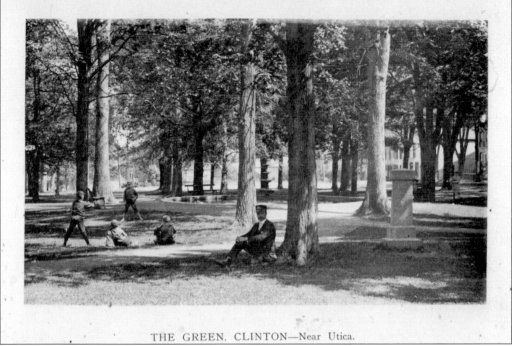

THE GREEN, CLINTON—Near Utica.

There is little doubt that the Park Hotel's location across from the tranquil and well-landscaped Village Green helped attract visitors. Here, a group of children play baseball while adults relax. During the late 1800s and early 1900s, Clinton and the hamlet of Kirkland became favorite summer vacation destinations. Many who came to Clinton for a peaceful summer vacation would use the famous landmark hotel as their home.

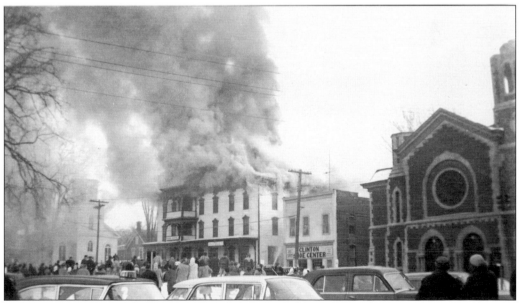

A devastating fire in the winter of 1961 destroyed the Park Hotel. A familiar sight for well over a century, it is now the location of the village parking lot across from the Clinton Historical Society.

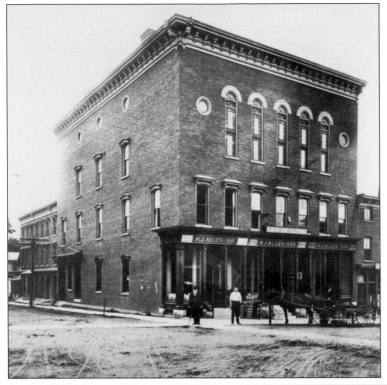

The growing Hamilton College campus lured builder Hiram Allen to Clinton. Requiring building materials, he realized the need for a hardware store and created the H.J. Allen Company. A true landmark occupying the first floor of the Onyan Block, it became a major part of town life for decades. This building housed other businesses, including an opera house and a Masonic temple. It was also the first home of Clinton's early fire department from 1895 until 1921, positioned in the structure's rear section on Williams Street.

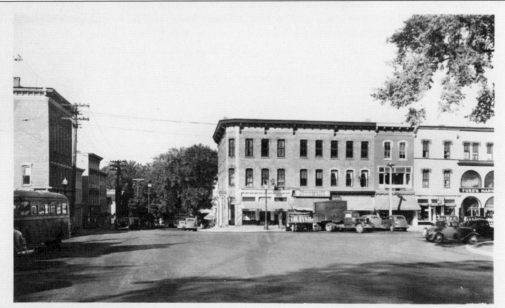

WEST PARK ROW AND COLLEGE STREET, CLINTON, N. Y.

Now a major international corporation, the Bristol Myers Company began in 1887 as the Clinton Pharmaceutical Company on the second floor of the Taylor Block on West Park Row. William M. Bristol and John R. Myers, both Hamilton graduates, employed about nine people in what was affectionately referred to as "the pill factory." The business was later moved to Syracuse and, eventually, New Jersey.

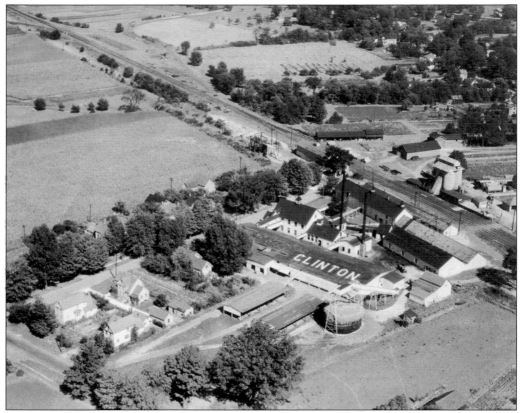

Opened on July 31, 1891, and closed in 1937, the Clinton Canning Company became an important opportunity for local farmers to process the bounty of the town's rich farmland. In this aerial photograph, one can see its identifying letters on one of its McBride Avenue buildings. These letters were helpful for early airplane pilots before the development of radio communication.

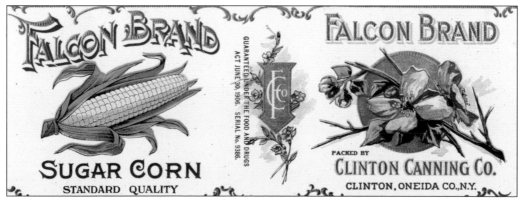

These recognizable labels were used on the many thousands of cans that left the Clinton site for kitchens far and wide.

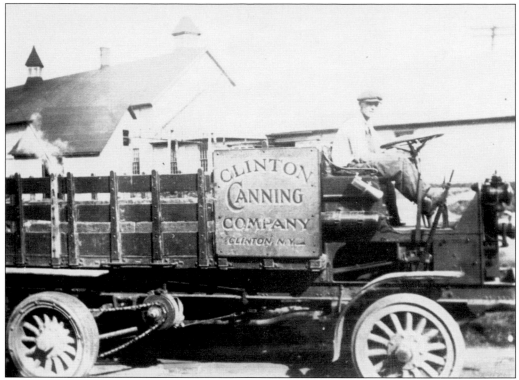

An early chain-driven truck is loaded down with the products of the Clinton Canning Company, which employed over 150 people. Records from November 9, 1897, reported that annual production included 25,000 cases of corn, 1,000 of tomatoes, 1,200 of peas, 200 of pumpkin, and 400 of currant jelly (all at 12 cans per case).

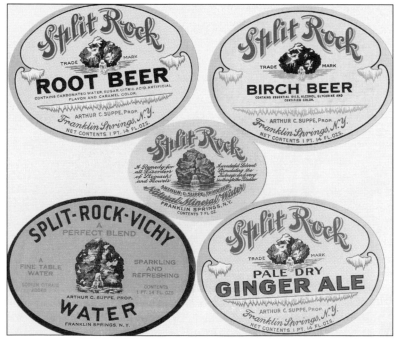

When Frederick H. Suppe had a new well drilled for his livestock on his farm along the Dugway Road in 1888, he didn't anticipate finding naturally carbonated mineral water that rivaled the best imported waters from Europe. It created a lucrative new industry that he labeled "Split Rock."

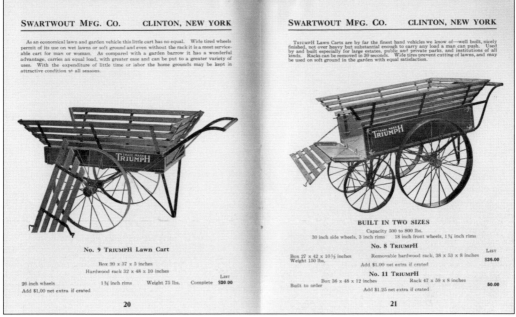

A manufacturer of well-made and affordable handcarts for industry and even more elaborate tea carts, the Swarthout Manufacturing Company was located on Dwight Avenue. Its top-of-the-line Triumph-brand carts were finished with dark-green boxes with varnished wood accents. Building its first cart in 1909, it featured metal gearing parts such as axles and springs painted a vivid red, making for a distinctive and attractive color combination.

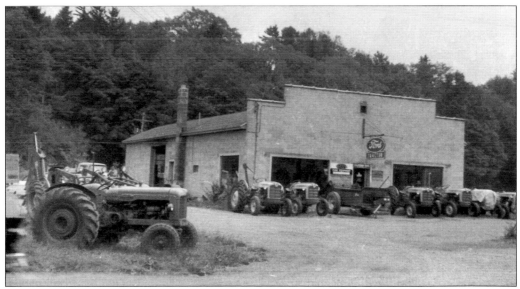

This photograph was taken in 1953, the year the Calidonna family started their farm implement business at the site of the first outdoor community skating rink on Meadow Street. Although the number of farms in New York State has declined from 114,000 that year to the current USDA's National Agricultural Statistics Service estimate of 36,000, Clinton Tractor and Implement Company has continued to grow by establishing a strong reputation for fairness and service. Many of the early tractors shown in this photograph are still operating.

This distinctive building with its petite footprint has been affectionately known as the "Dental Office" for over 100 years. Originally built by Dr. John Beardsley and then occupied by his nephew Dr. J.N. Garlinghouse, it also served as the office of Dr. James Francis, who practiced dentistry for over 70 years in Clinton. He was followed by Dr. John Menard, whose office is currently located on East Park Row.

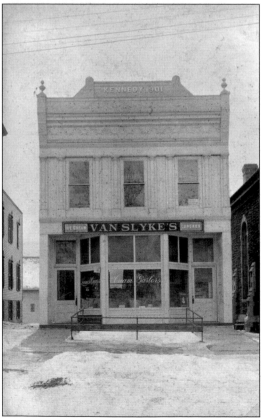

In 1901, O.W. Kennedy ran his hop business from this location. This was followed by the Kirkland Mineral Springs Company, which had its offices here, as well as a popular public soda fountain. Later, it housed a luncheonette catering to trolley travelers, as the stop was just across the street. Most recently known as the Vona Block, it was the dental office of Dr. Marty Vona for many years, and before that, it was his father's shoe store.

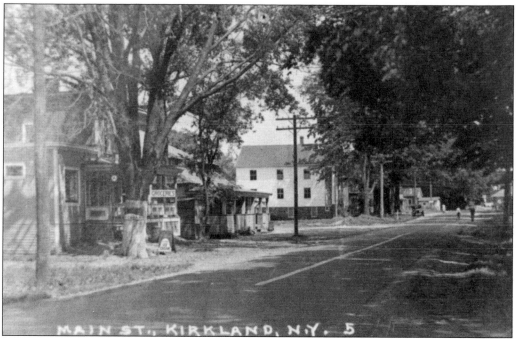

The hamlet of Kirkland was a popular vacation and weekend getaway destination in the early 1900s, offering two large dance halls, tourist homes, a feed store, a blacksmith shop, a creamery, and other attractions. Looking east toward Utica, this 1920s-era photograph features Grace Wood's grocery store and the large, whitewashed Congregational church.

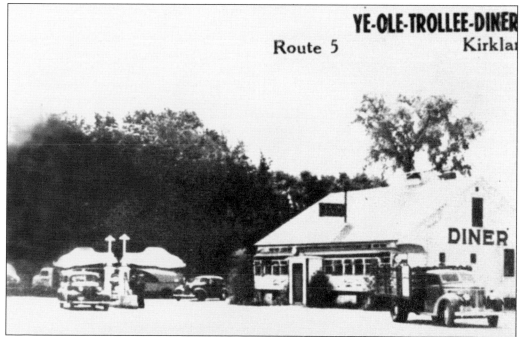

Also located in Kirkland (formerly Manchester), Ye Ole Trolley Diner was operated by brothers John and Peter DeCarlo. It was on the south side of Route 5 on the site of the former Dowling's Tavern and the present-day Ironwood Furniture store.

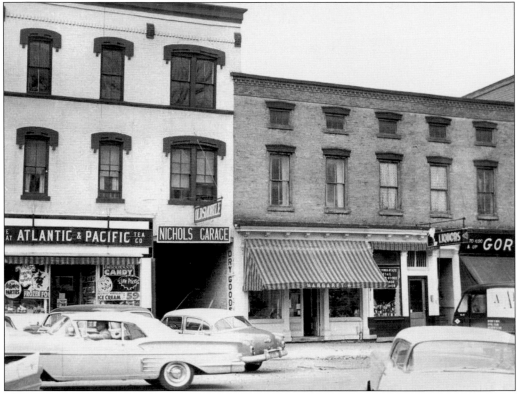

This 1954-era photograph shows a number of businesses along West Park Row during this time period, including the A&P grocery store located in a part of the Clinton House building from 1934 until the late 1950s. Nichol's Auto Company was located behind West Park Row and was accessed via the tunnel.

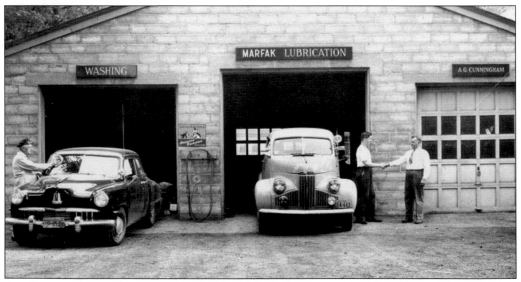

Art Cunningham sold Studebaker cars and trucks during the 1940s and 1950s from his dealership at 101 College Street near the Oriskany Creek Bridge. An innovative American car company, Studebakers were sold from 1902 (an electric model) until March 16, 1966.

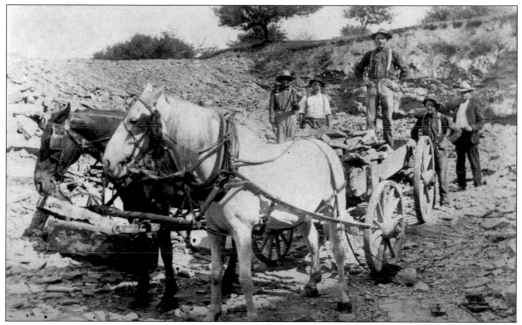

Several limestone quarries developed in town, including one from the 1800s that was operated by the Dawes family. Cittadino Quarries had one of its large limestone quarries at the top of Fountain Street, which produced thousands of tons per year for a variety of building projects including Griffiss Air Force Base, the General Electric plant, and other regional industrial complexes. One of their smaller quarries on Cleary Road off Brimfield Street produced much of the stone for construction at Hamilton and Kirkland Colleges from the 1950s through the 1970s.

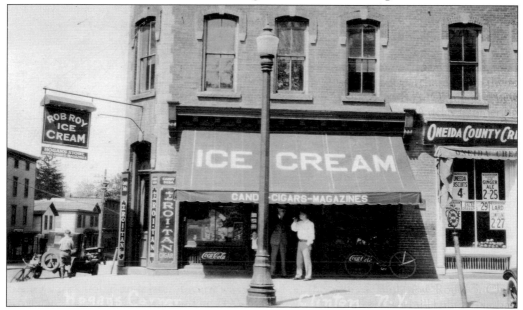

Without question, the main center of activity in the town and village is the intersection of West Park Row and College Street. Originally the site of the Foote family's log cabin and early tavern, it is perhaps most famous as Hogan's Corner, named in tribute to the popular ice cream, cigar, and confectionery store run for many years by the kind Hogan family.

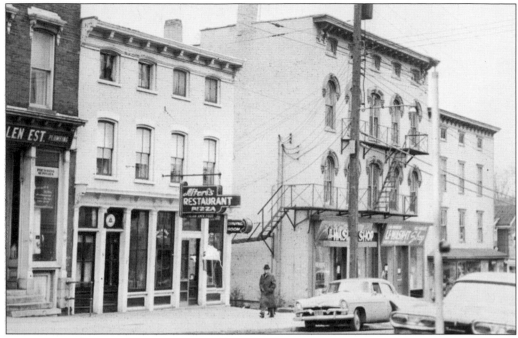

Since 1953, a favorite place for great food has been Alteri's Restaurant. When Fred Alteri located his business here in 1953, it was in the 1883 building immediately west of the Onyan Block on College Street. The family's quality Southern Italian–style cooking became an immediate hit. Although the original structure was destroyed by fire in 1963, it was rebuilt and is now operated by Fred's son Fran.

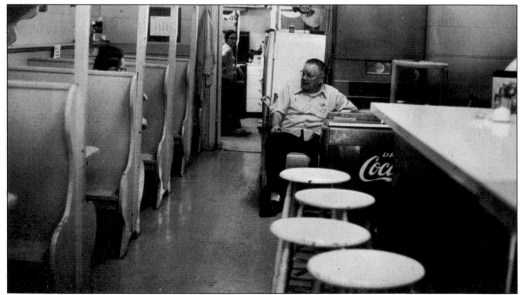

At Stan's Sweet Shop, owned by Stan Millard, one would find the West Park Row landmark packed with residents enjoying a breakfast or lunch while conversing with friends, as well as students jammed into the many booths as they did their homework and enjoyed a milk shake. His longtime waitress Joyce Creaser was loved by all. As valedictorian of her class, Joyce often helped students with their homework. Here, Stan is seen taking a well-deserved break.

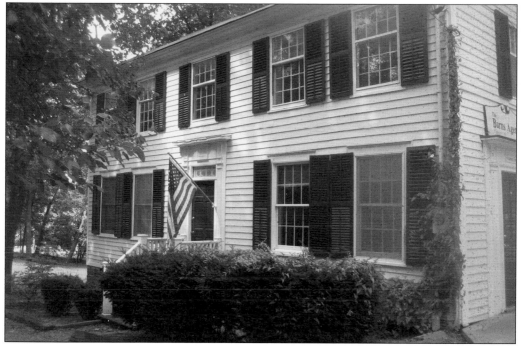

This former law office of Othniel Williams was built in the 1790s. This building has seen a variety of other uses, including as one of Clinton's early grammar schools. It now is home to the Burns Agency, an independent insurance agency founded in 1919 by O. Gregory Burns, a prominent Clinton attorney. The agency grew when Gregory's son Nicholas K. Burns Sr. joined in the early 1950s. It is now run by David Burns, one of Nicholas's sons. He and his staff have carefully maintained the integrity of this historic building.

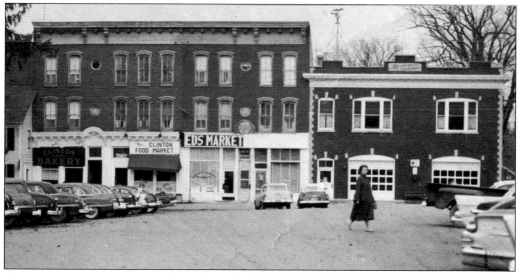

Welcome Amos Ferguson purchased the Clinton Home Bakery in 1949 upon his discharge from the US Navy, where his baking skills made him one of the most popular sailors on his ship. Known for his many acts of kindness, such as preparing coffee and donuts for the firemen when they returned from fighting a fire, he operated the popular business on North Park Row until the mid-1960s, when he sold it to Jacobus Verhoeven.

George Mair first opened his barbershop on July 9, 1964, at the earlier site of Stan's Shoe Shop. It has served the community ever since and enjoys a loyal clientele, many of whom had their first haircut under Mair's skilled hands. A car enthusiast, Mair tastefully filled his College Street shop with a variety of American racing memorabilia. To the left in the photograph is the current home of the Clinton Jewelers. This had been home to the College Inn, a popular candy and soda fountain.

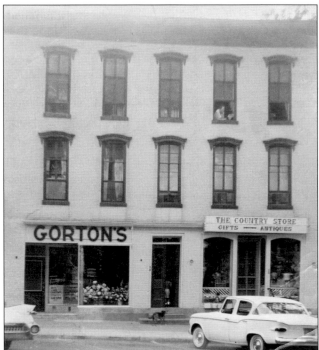

Gorton's Variety Store was purchased from the Donald Gorton family by Vincent and Virginia Romanelli on January 1, 1977. Virginia acted as the store manager and expanded the already incredible inventory to include just about anything a family might need. The entire town was saddened when the store closed in late 1986.

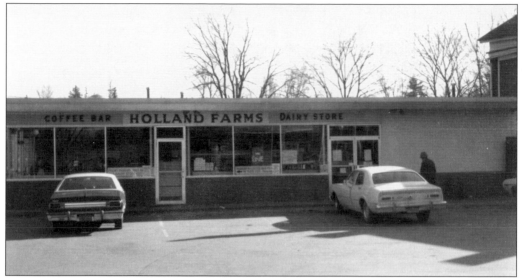

Holland Farms opened on the site of the present-day Clinton Post Office on November 15, 1963. Its luncheonette was a favorite gathering place, always filled with a combination of community members and students from the nearby school.

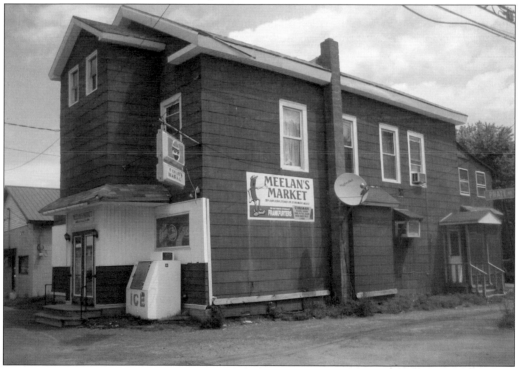

Meelan's Market has been a real treasure for three generations. Known for its high-quality meats and homemade foods, it is located in what is believed to be the oldest existing building in the hamlet of Clark Mills. It is operated by master butcher and Kirkland town supervisor Robert Meelan, who purchased it from his mother, Leona, upon the death of his father, Edward. Its popular homemade meat and Mideastern products draw customers from throughout the region. (Courtesy of Frank Cittadino.)

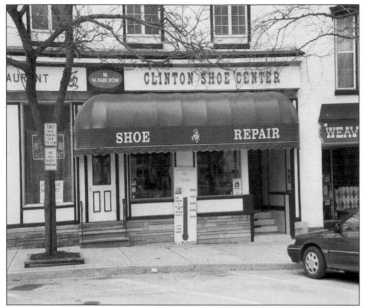

Clinton mayor Jack Lane has operated the Clinton Shoe Center in this location at the Scollard Opera House since he moved from his original shop on North Park Row in 1987. Lane, a master cobbler who has made custom leather shoes, can expertly repair anything made of leather. His store also carries a full line of quality brand shoes.

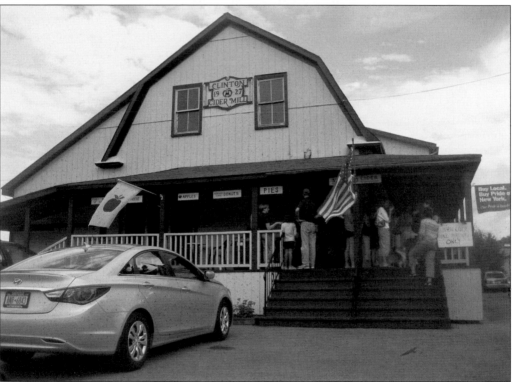

Years ago, nearly every local farm had an apple orchard. Apples were turned into cider, adding variety to early tables and vinegar that aided in food preservation. John and Mimi Felhner and their family have rescued the historic Clinton Cider Mill, established in 1903 by the Wentworth family on Elm Street, along with its museum-quality apple press, and have turned it into one of the highlights of community activity during the fall months with cider and tasty baked goods. (Courtesy of Faye Cittadino.)

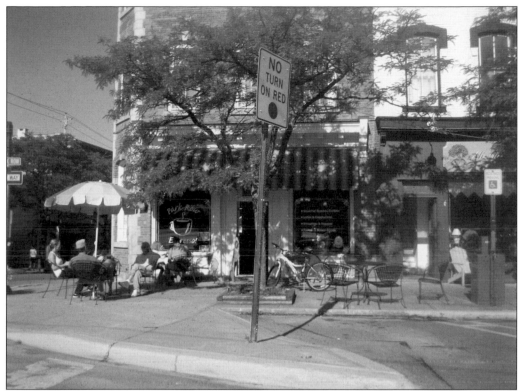

Hemstrought's Bakery, located at Hogan's Corner for many years, was part of the Utica-based business famous for inventing the Half Moon Cookie, a soft, spongy cake with half chocolate and half vanilla icing. Today, Park Row Espresso carries on the tradition of excellent coffees and great food. (Courtesy of Faye Cittadino.)

Started by the Calidonna family in 1953, the Clinton Tractor and Implement Company has become a major supplier of agricultural machinery in the Northeast. It also carries a line of quality homeowner lawn maintenance products. The business recently expanded into the adjacent Chevrolet dealership and occupies the entire eastern end of Franklin Avenue and Meadow Street. (Courtesy Frank Cittadino.)

Originally named the *Clinton Signal*, then the *Oneida Chief*, and finally the *Clinton Courier*, the weekly newspaper has played a major role in the life of the community since 1846. Owned and operated by Cynthia and Charles Kershner since 1992, the *Clinton Courier* is the longest continually operating business in town.

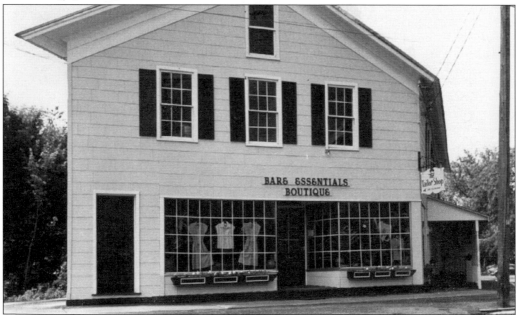

This unusually shaped building has seen many uses since its construction on the east side of the busy intersection of the Chenango Canal and College Street. Currently, it is a dry cleaning and tailor shop. Past uses include a canal warehouse and, later, a milk station where area farmers lined up each morning with their pickup trucks filled with fresh milk.

Six

Agriculture and Mining

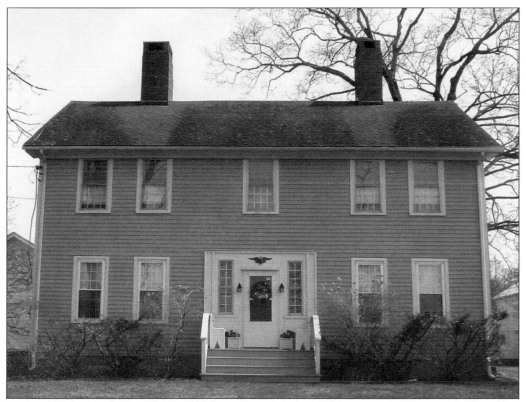

This stunning example of early American Federal-style architecture is the Barnabas Pond homestead, lovingly restored and maintained by present owners Jean and William Kay. This eight-post plank structure was built in 1794 by the son-in-law of founder Moses Foote. Pond arrived with his bride, Thankful, and the original group of eight families to settle this new land. It features the original hand-forged hinges and hardware, as well as original floors and over 12 windows. (Courtesy of Faye Cittadino.)

This interior of the Barnabas Pond homestead shows the careful attention to detail to retain the original character and furnishings of this remarkable home, complete with its hand-forged hardware. (Courtesy of Frank Cittadino.)

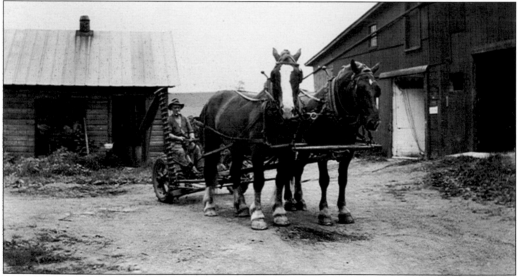

Long before the use of modern equipment, this Kirkland farmer is about to tackle one of his hay fields with his trusty horses and sickle bar mower. The sickle bar was propelled by the wheels of the mower.

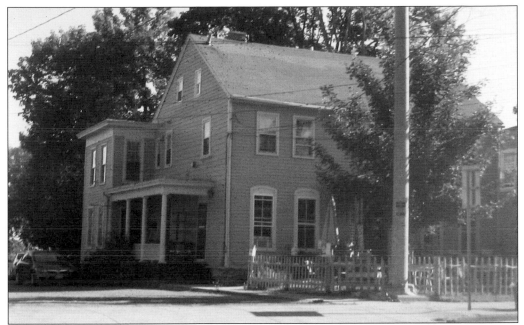

This is the original farmhouse of Ozias Marvin, located on College Street across from Marvin Street.

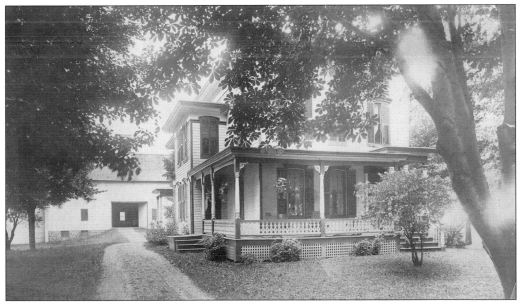

This photograph of the Carpenter Farm on Seneca Turnpike shows a neat and tidy farmhouse and barn owned by the grandfather of Clinton businessman Robert Ford. During the 1960s, the farm was used for location shooting of the Hollywood film *Sterile Cuckoo*. It is still standing as clean as ever at the corner of Route 5 and Limberlost Road.

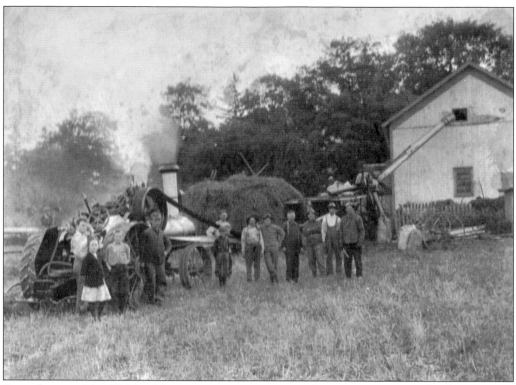

Several enterprising Kirkland farmers were eager to use modern steam-engine technology to assist with labor-intensive tasks. Pictured here is an early steam-powered thresher owned by Erwin H. Sawyer of Sawyer Road in the late 1800s.

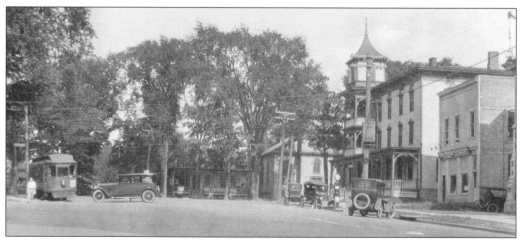

The busy intersection of Fountain Street, Kellogg Street, and College Street/Route 12B was a popular one for area farm families when they came to town during the early 1900s. The Park Hotel provided an elegant site for dining out, while the luncheonette in the adjacent Kennedy Block provided for a more casual lunch. Behind the Park Hotel was the local chapter of the Grange, which was established as a meeting place for farm families. Across the street from the Park Hotel was the trolley stop, providing half-hourly rides to Utica and communities northeast of the village.

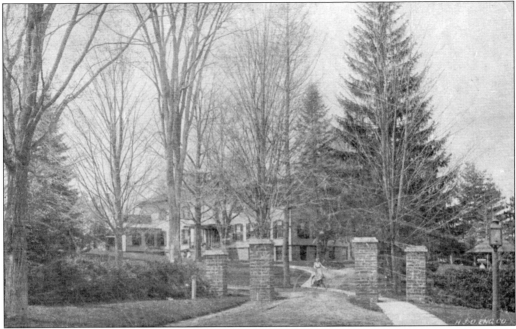

Originally the stately farm of Hamilton College founder Samuel Kirkland, the property was sold to Lyman S. Harding by the Honorable Elihu Root.

Images such as this early poultry barn located on the original Jones Farm on Brimfield Street reflect a time when there were many family farms of all sizes throughout the town. For many farmers, it was not worth the effort to maintain chickens due to the number of natural predators in early America. The farm is now owned by the Harris family.

An early farm on Skyline Drive succumbs to the challenges of nature and is about to become one with the land it helped develop. Pictured during the 1930s, Skyline Drive was a dirt road. One of the most dramatically beautiful parts of the town, its rolling hills and fertile fields remain

actively farmed. The magnificent views from Skyline Dive have also made it a popular site for new housing.

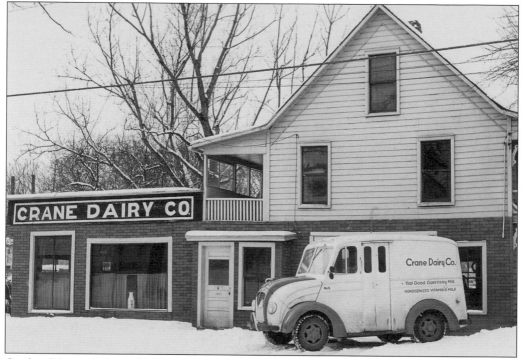

On land farmed since the Revolutionary War, the Crane family continues to operate their productive farm on College Hill Road just past the Hamilton College campus. From the mid-1940s until 1973, they also operated a popular dairy with a bottling plant on Griffin Road and this store and garage on Meadow Street. With a fleet of eight specially designed Divco delivery trucks, the Crane Dairy had over 2,300 customers throughout central New York.

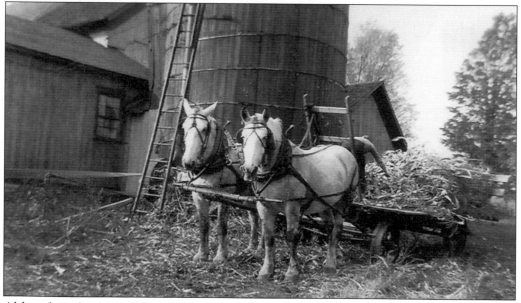

Although no longer considered a farming community as much as a college town and bedroom community for professionals working in Utica and Syracuse, much of the fertile land, especially in the southern part of the town, still supports a number of very productive farming operations.

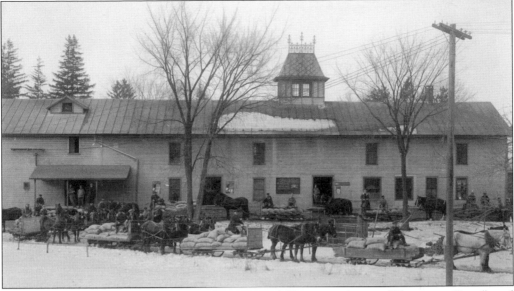

The location of the present Agway at the corner of Chenango Avenue (Chenango Canal) and Kirkland Avenue (formerly Water Street) has been the site of agriculture-related businesses for well over 150 years. In this late-1800s photograph, area farmers stop by to obtain feed and other farm related necessities to get through the winter months.

Started after the Civil War, the Grange began as the Order of the Patrons of Husbandry and had a local chapter in the building that later housed the Cannonball Theater at 4 Fountain Street. Combining social opportunities for early farm families and the promotion sound farming practices, it was one of the first organizations to admit women at an equal status as men. With the decline of farms in the town, membership also declined, and the local chapter closed. This building later became the popular Cannonball Theater and currently is a professional office building owned by Jay and Sally Anderson.

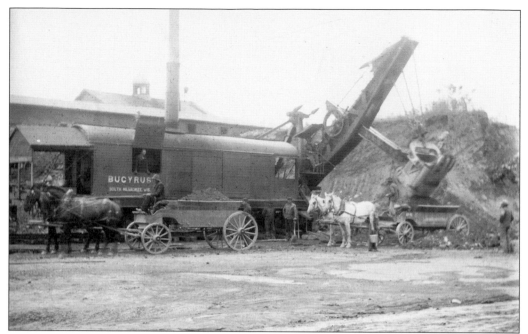

A farmer plowing his field brought about the discovery of iron ore in town. This photograph, taken at the Borst Mine off Brimfield Street behind the present-day Lutheran Home, shows the huge Bucyrus Erie steam shovel, which could load a wagon of raw iron ore with one bucketful and send it on its way.

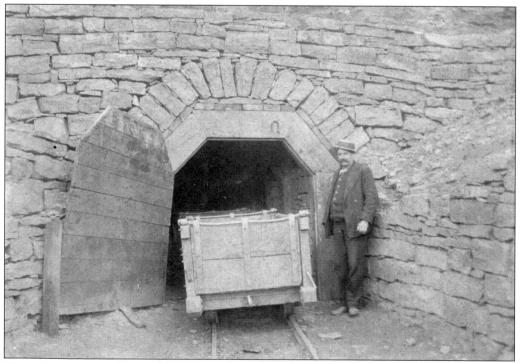

Pictured here is one of the early mine cars that ran on miniature railroad tracks. It took many trips each day to supply the hungry blast furnaces at the hamlets of Franklin Springs and Kirkland.

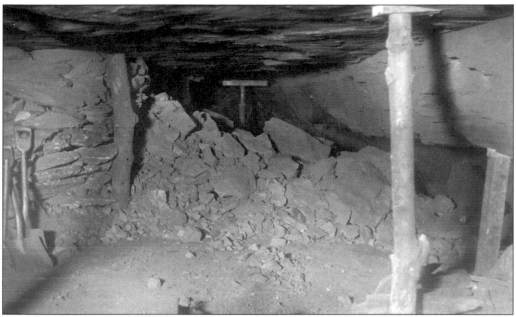

This photograph provides a rare view of the actual environment inside one of the mines. Workers would descend into the mine using several 10-foot-long steel ladders to reach the ore and then have to climb back up at the end of a typical 10-to-12-hour day.

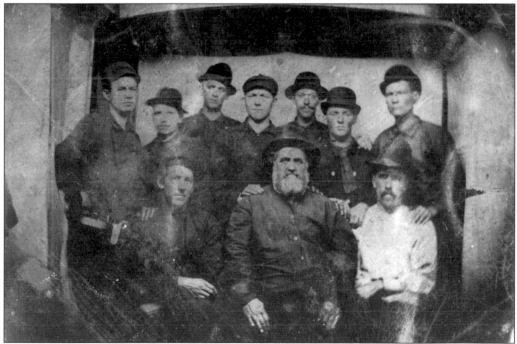

The faces of these early miners clearly reflect the hardworking and independent men who had the courage to venture deep under the town to extract the iron ore so important to the country's industrial growth. There was no question that the mining industry provided yet another avenue of employment for the town's growing population. It also attracted new immigrants experienced with mining processes in their native Wales and Ireland.

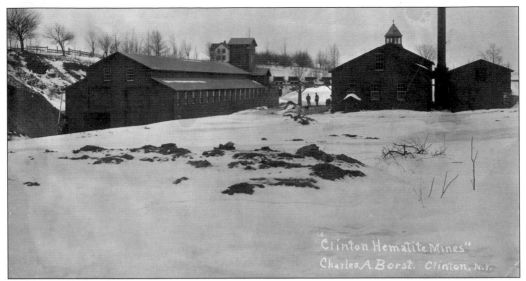

Located behind the present-day LutheranCare was the Borst Mine. It was so productive that a special railroad siding was run by the Ontario & Western Railroad (O&W) from the main line, which followed the Chenango Canal.

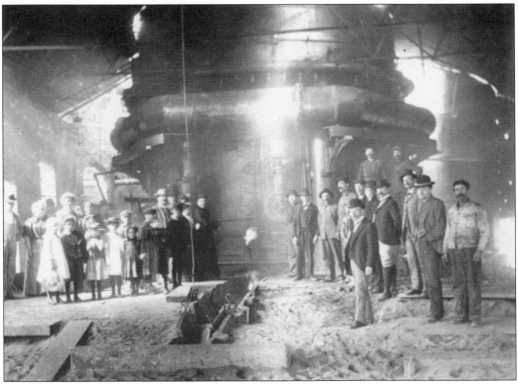

This unusual photograph of women, children, furnace workers, and dignitaries may have been taken during the dedication of the newly improved Franklin Blast Furnace. Iron ore, coke, and limestone (used to remove impurities) would be fed into the top of the tower. A mixture of pure iron ore and waste products called slag are formed. The huge quantities of slag produced created another industry, as it was crushed and used as building material.

When this aerial photograph was taken, the hamlet of Kirkland was a bustling place. The huge blast furnace is seen in the upper right. Located near the present-day intersection of Route 5 and Kirkland Avenue, it operated from 1878 until 1898, producing as much as 15 tons of pig iron per day.

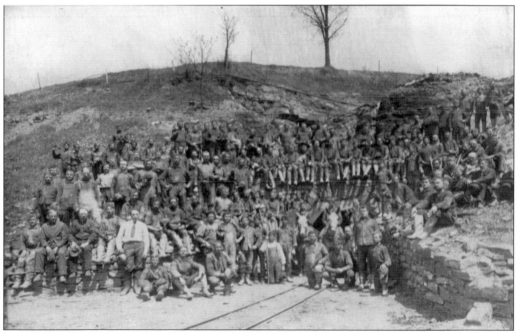

A source of employment for many new emigrants from Wales and Ireland, the discovery of a higher-grade iron ore along Minnesota's Mesabi Range had a negative impact on the local mines. However, the ore was used to manufacture other products, such as the famous barn-red paint that beautified and protected so many American barns and a coloring oxide for brick and mortar produced by the Clinton Metallic Paint Company. The mining industry ended in the town of Kirkland in 1963.

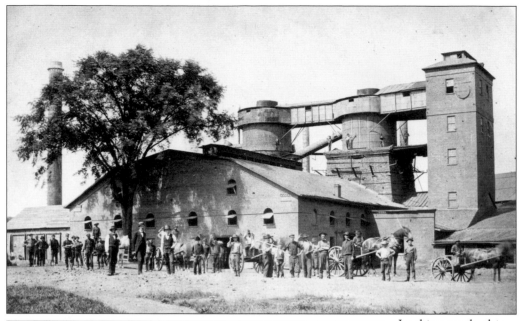

Looking north, this 1878 photograph provides an idea of the size and complexity of the Franklin Furnace. Operating from 1852 until 1913, it defined the hamlet of what was then known as Franklin Foundry.

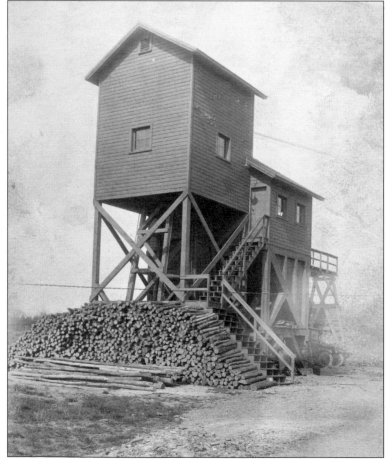

Until its dismantling in the 1980s, the only evidence of the Town of Kirkland's mining industry was this mine entrance at the corner of Dawes Avenue and Brimfield Street and large slag piles in Franklin Springs that were crushed and used in driveways and other construction projects.

Seven

TRANSPORTATION

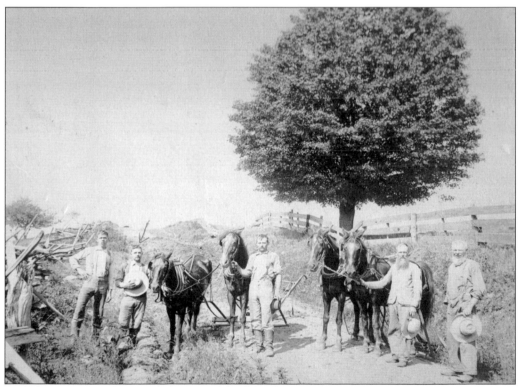

Early farmers not only provided essential food for their community but were also a major force in maintaining the network of early roads that passed through their fields. Spring thaws and heavy rains often made these early roads impassable. Eventually, some areas were replaced with corduroy roads consisting of logs laid alongside one another. Later still, the construction of one of the first plank roads in the nation took place, running from Utica through Clinton and Dansville to Waterville, complete with tolls, and operating from 1848 until 1878.

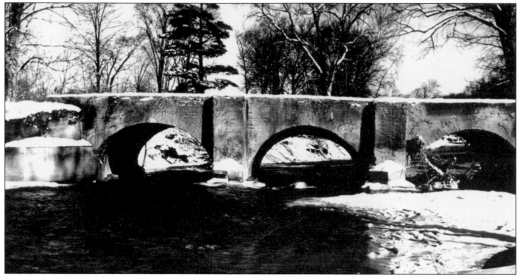

Crossing the Oriskany Creek on College Street was necessary for travel between the west and east areas of the town. Early crude bridges were replaced with this Roman-arched concrete structure.

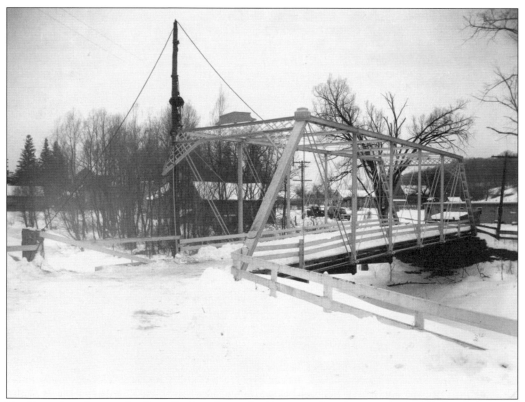

Fondly referred to as the First Bridge along the Dugway, this sleepy and extremely picturesque area was known as Red Mill, Farmer's Mills, and Milbourne (from the Scottish word for stream or brook) and was the site of bustling manufacturing, including a sawmill, chair factory, trip hammer, and gristmill.

A drive past the First Bridge over the Oriskany on the Dugway Road makes it clear how this early road obtained its name. Farmers from the south and west of the First Bridge wanted a shorter route to get to the gristmill and other businesses located there. This was impossible, as the high hills plunged steeply into the Oriskany Creek. Not to be discouraged, they organized their own excavation and created the cliff-hugging road that leads the short distance between the First and Second Bridges. (Courtesy of Faye Cittadino.)

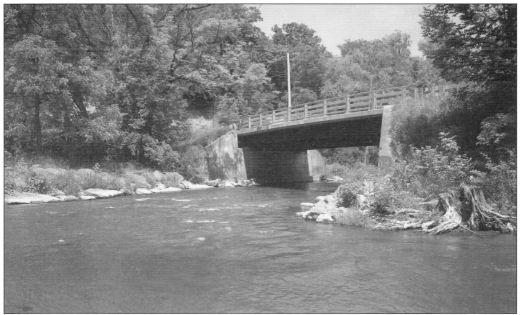

This modern photograph of the Second Bridge on the Dugway, immediately southwest of the First Bridge, was taken during the summer months and shows Oriskany Creek flowing toward the First Bridge. Formerly known as Keeler's Bridge, the original was inches above the water, which reportedly flowed over the bridge during times of high water levels, making passage quite a fright. (Courtesy of Faye Cittadino.)

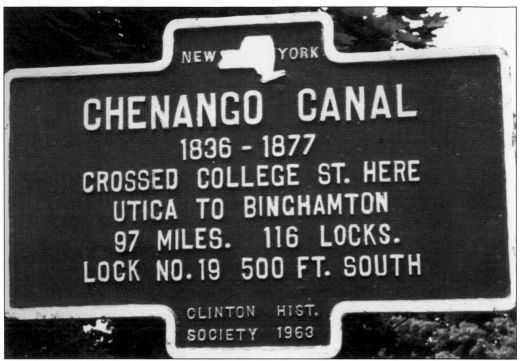

This New York State historical marker reminds residents and visitors of the Chenango Canal's important contribution to New York State history.

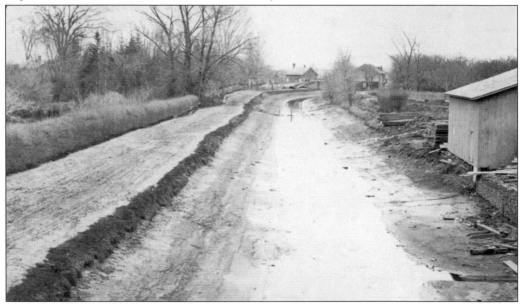

In operation from April 1836 until 1877, the Chenango Canal became a valuable north-south transportation route from Utica to Binghamton. By connecting with the Erie Canal in Utica, it essentially linked the major manufacturing and urban areas of New York and played a major role in the development of the young United States. Good shipped north to Clinton and Utica on the Chenango Canal included salt and coal, while iron ore, timber, and farm products headed to southern markets on the flat-bottomed canal boats.

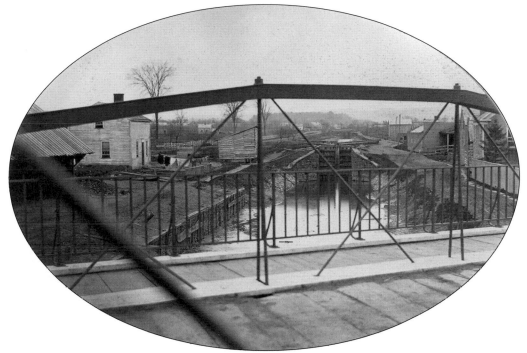

This view looks from the busy College Street Bridge southwest toward Franklin Springs and Lock 19. A large warehouse and a wide basin to allow boats to be turned around were located here. Although the canal was constructed primarily for the transport of goods and not passengers, many Civil War soldiers from this part of New York State were transported toward southern battlefields on the Chenango Canal.

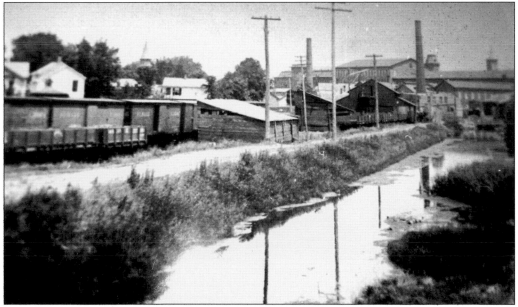

This view faces the opposite direction—east toward Water Street (now Kirkland Avenue) with the towpath on the left. Further left of the towpath was the Cottage Seminary, now the public school campus.

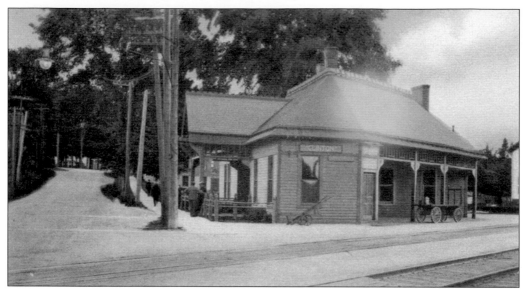

The advent of train travel made canal travel obsolete. The Utica, Clinton & Binghamton Railroad (UC&B) first reached Clinton on September 3, 1866.

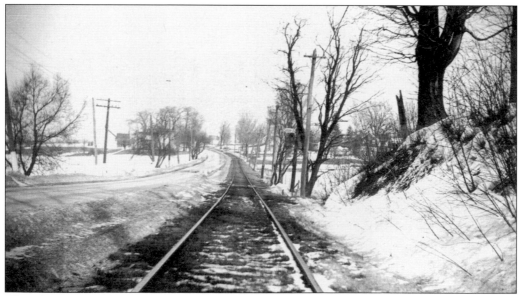

This photograph shows trolley stop no. 7 on the Clinton-to-Utica route. Riders claim that the trolley would really pick up speed on this straightaway heading to New Hartford and, eventually, Utica.

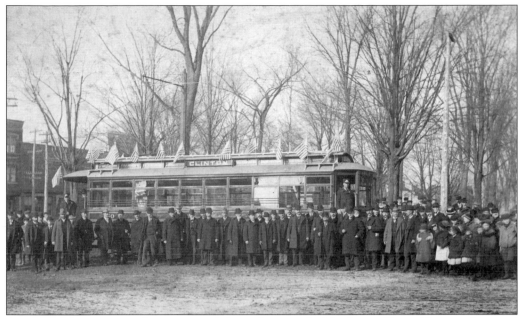

A crowd of dignitaries and spectators celebrate the arrival of the first trolley to Clinton. A special luncheon was provided at the Willard House, later known as the Park Hotel, on South Park Row. Trolley service between Utica and Clinton began on December 12, 1901, and provided relatively smooth and dependable transportation, with service from Clinton's Village Green to Utica's Union Station every 30 minutes.

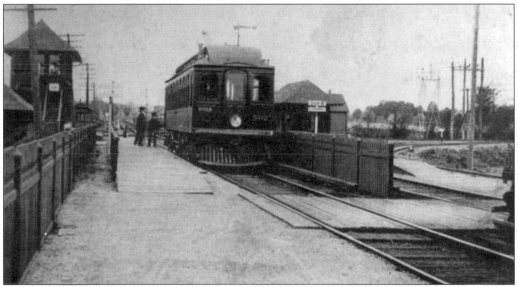

The trolley stop in Clark Mills connected that bustling hamlet with Whitesboro, Utica, and of course, Clinton. The Hind & Harrison Plush Company would occasionally provide excursions for its employees and their families, using the trolley to connect to trains heading toward area recreation spots such as Sylvan Beach. Operated on the Electrified West Shore (or Third Rail System), trolley service began on June 15, 1907, and continued until December 31, 1930. All eastbound and westbound cars heading to Utica or Syracuse stopped in Clark Mills. This explains the large size of this trolley, referred to as an interurban.

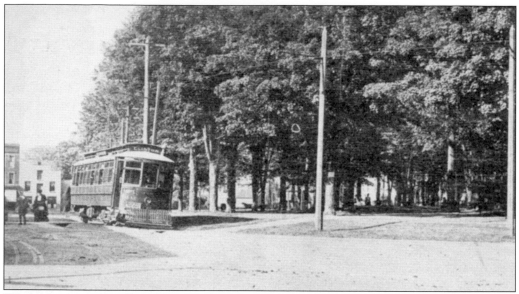

While the summer trolley was open, the winter trolley provided protection from the elements. Trolley service to Clinton ended at 12:30 on Sunday morning, March 22, 1936.

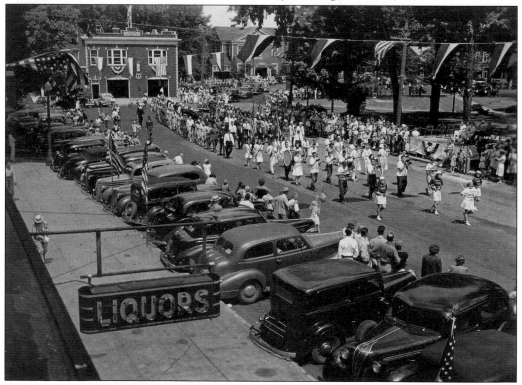

July 4, 1946, saw the town bursting with pride and relief as local soldiers returned home from the war and were recognized with a welcome home parade. By this time, the automobile had already started to change the development of the United States, and the Town of Kirkland was no exception. Its attractiveness as a great place to live and raise a family drew newcomers from nearby Utica, Rome, and eventually, Syracuse.

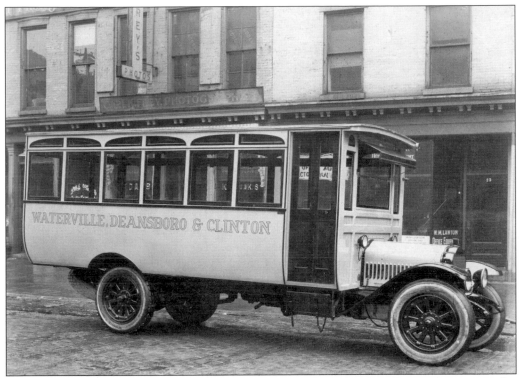

Replacing the horses and carriages used to transport travelers toward southern communities, the Waterville-Deansboro-Clinton bus provided an essential link to the Clinton trolley stop from September 1913 until the mid-1920s.

Carefully making the turn from Park Row onto College Street, this Town of Kirkland Highway Department snowplow is piloted by one of many dedicated employees of the town and village departments of public works who work so hard to insure safe travel and a beautiful community throughout the year but most especially during the winter season.

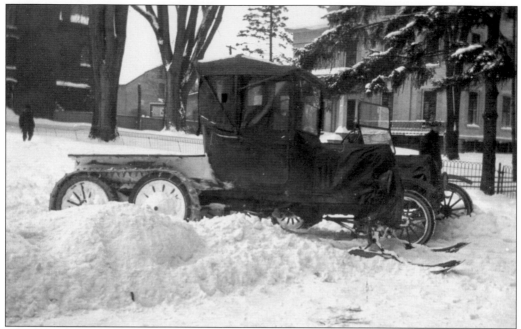

The creativity of early town mechanics is legendary, as evidenced by this solution to mail delivery on snowy winter roads: a Model T roadster modified with skis on the front and a third axle with chains on the rear wheels.

An old-fashioned winter tests the power of the town's huge Walter Snow Fighter after a February 1936 blizzard on Chuckery Corners. Such challenges were common at some of the town's other higher elevations, such as Skyline Drive and Paris Hill.

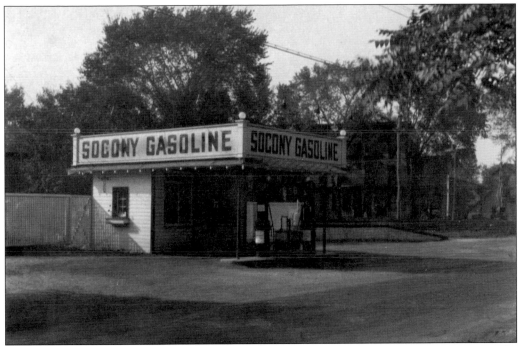

Located between the current Homestead Bank and the Access Federal Credit Union was Jake Schilling's first gasoline station on Franklin Avenue. The view across the street shows the Keith Block and the railroad-crossing gates at College Street.

Noah Clark's home and, later, tavern was located on the Seneca Trail, now Route 5. Clark arrived in Thompson's Mills in the late 1790s to take over a gristmill and sawmill built by Nathan and Ebenezer Thompson two years earlier. He later purchased additional land from George Washington. His son Bailey started the first cotton mill there in 1846. In 1893, the name was officially changed to Clark Mills. This structure was destroyed in a fire in 1987. (Courtesy of the Clark Mills Historical Society.)

Discover Thousands of Local History Books
Featuring Millions of Vintage Images

Arcadia Publishing, the leading local history publisher in the United States, is committed to making history accessible and meaningful through publishing books that celebrate and preserve the heritage of America's people and places.

Find more books like this at
www.arcadiapublishing.com

Search for your hometown history, your old stomping grounds, and even your favorite sports team.